IMAGES
of America

LONG BEACH
ART DECO

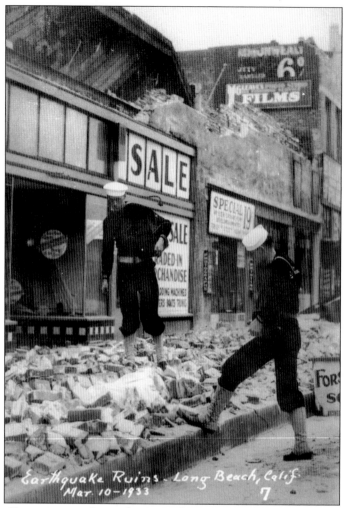

Earthquake Ruins - Long Beach, Calif.
Mar. 10-1933
7

SAILORS AFTER EARTHQUAKE. It was fortuitous for Long Beach that the U.S. Navy happened to be anchored just offshore when the earthquake hit. The sailors were able to act as police and emergency crews, preventing looting and, no doubt, saving lives. Motion-picture studios sent portable lights to enable the sailors and other workers to continue their labors at night. The Borden Milk Company contributed gallons of milk and help poured in from other cities. Santa Paula dispatched a truck filled with sandwiches, milk, and orange juice; the Southern California Bakers Bureau sent 30 truckloads of bread to feed residents displaced by the quake and the people who were digging out the city and ministering to the wounded. The schools were badly damaged, but only one student was killed as a result of a collapsing school building. Tony Guglermo, a 17-year-old boy, lost his life in the shower room at Wilson High School no more than 10 minutes after he soared 8 feet, 6 inches to take fourth place in a pole vault. (Postcard uncredited.)

ON THE COVER: When this picture was taken on October 22, 1930, the Rowan Building at Pine and Broadway was not quite completed. Brilliant and fanciful terra-cotta tile was already drawing attention to the upper story, but construction was still evident on the ground floor. Painters from W. B. Walters were busy with their brushes, laboring alongside carpenters and other workers supplied by builder Charles W. Pettifer. (Courtesy Stan Poe.)

IMAGES
of America

LONG BEACH
ART DECO

Suzanne Tarbell Cooper, John W. Thomas,
and J. Christopher Launi

ARCADIA
PUBLISHING

Published by Arcadia Publishing
Charleston SC, Chicago IL, Portsmouth NH, San Francisco CA

Printed in the United States of America

Library of Congress Catalog Card Number: 2006926311

For all general information contact Arcadia Publishing at:
Telephone 843-853-2070
Fax 843-853-0044
E-mail sales@arcadiapublishing.com
For customer service and orders:
Toll-Free 1-888-313-2665

Visit us on the Internet at www.arcadiapublishing.com

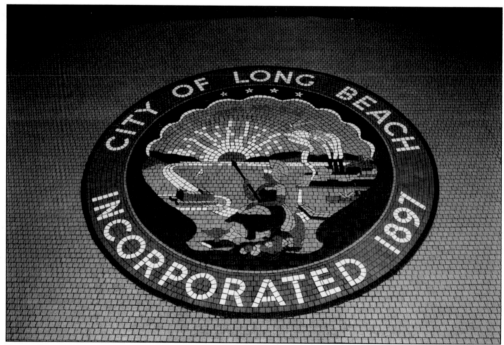

CITY SEAL OF LONG BEACH. The city seal at the airport terminal's entrance is one of the few mosaics by Grace Clements still visible. During the 1980s, the city logo reflected its unofficial motto, "Out with the old, bigger is better," with three high-rises. The original seal was brought back recently with a few changes: factories no longer emit smoke, and four stars, signifying California's fourth-largest city, have disappeared.

CONTENTS

ACKNOWLEDGMENTS

A lot of wonderful people contributed their time, talents, photographs, and information to the realization of this book. First and foremost, we wish to thank Frank Cooper, who put in almost as many hours and effort as those of us with our names on the cover. We also wish to thank Stan Poe, Louise Ivers, Maureen Neely, the John Parker family, the Historical Society of Long Beach, Long Beach Heritage, the City of Long Beach Public Library, the RMS Queen Mary Foundation, the Long Beach Unified School District, the Long Beach Airport, the *Los Angeles Times* Archives, Diane Threadgill, Jim Hilliker, Jerry Roberts, and the Art Deco Society of Los Angeles. Amy Ronnebeck Hall and Celeste Hong provided peerless support, suggestions, and proofreading. And finally, Logan Cooper—yes, you can use the computer now.

ABOUT THE AUTHORS

Suzanne Tarbell Cooper is a longtime board member of the Art Deco Society of Los Angeles and a coauthor of *Los Angeles Art Deco*.

John W. Thomas is the owner of Art Deco Dimensions in Long Beach, as well as vice president of the Art Deco Society of Los Angeles, vice president of Long Beach Heritage, and board member of the Historical Society of Long Beach.

J. Christopher Launi has won various regional and national awards for his photography. For a number of years now, he has been documenting the history of Long Beach

Unless otherwise noted, all photographs are courtesy of J. Christopher Launi.

INTRODUCTION

At 5:55 p.m. on March 10, 1933, a massive 6.25 magnitude earthquake rocked Southern California. Wood-frame bungalows lost their chimneys, and engineered concrete buildings had minimal damage, but unreinforced masonry buildings near the epicenter failed catastrophically. Long Beach was particularly hard-hit. People who had awakened in a town with a variety of building styles fell asleep that night in a landscape that must have appeared decimated. The stage was set for Long Beach to arise from the rubble as a Deco city.

The structures that collapsed completely or were damaged beyond repair were mostly built of brick and not designed to resist lateral stress; some were shoddily constructed with inferior mortar. Many had elaborate towers and architectural ornamentation that provided additional hazards, raining down bricks, plaster, and decorative elements in every aftershock. The hospitals were described as "bedlam" as people streamed in with injuries both minor and critical, but only about 120 people lost their lives amid collapsing buildings and falling debris. Navy personnel stationed just offshore were there immediately to help with disaster relief and policing. The fleet of 35,000 men, the "cream of the nation's power at sea," were scheduled to leave port on March 13th, but their "battle torpedo practice" was delayed to allow the sailors to stay on guard in the quake areas. The *Los Angeles Times* reported that, thanks to their presence, looting was minimal.

If the earthquake had struck earlier, when children were in school, the loss of life would have been tragically higher. Nearly three quarters of the city's educational buildings were destroyed. As a result, on April 10, 1933, the Field Act, named for the California Assembly member who was instrumental in its passage, was enacted. It stated, "Because schools are funded with public money . . . legislative statutes require children to attend schools, and the school buildings performed so poorly in the earthquake," all future school construction must be earthquake resistant. It was a good law—no Field Act school has ever collapsed in an earthquake.

The Art Deco style, in addition to being stylishly modern in 1933, also met the criteria of earthquake safety. Most Deco buildings were built of reinforced concrete, and decorations were integral to the architecture rather than separate pieces added on. Not everything built during the era, of course, was Deco. Unless a city had stringent rules governing design, like Santa Barbara, which mandated a Spanish Revival style when it was rebuilt after a 1925 quake, people constructed what they liked. Sometimes this was a traditional style—Tudor, Mediterranean or French Renaissance—but frequently the prevailing mode won out, which is how Long Beach ended up with a multitude of Art Deco buildings as well as fine examples of buildings designed in Revival styles. People's lives do not fit into neat boxes, and neither do the cities they build. Some structures have been included here because they were important during the era, even if they are not recognizably Art Deco.

There were two primary Art Deco styles. Zigzag Moderne, which reached the height of popularity in the 1920s, featured straight lines with decorative towers and setbacks. Although lavish and expensive materials were often used, many buildings featured bas-reliefs in concrete, stone, or brightly colored terra-cotta that were carved, molded, or inset directly into the walls. By the

1930s, the machine age was a fact of life, celebrated in art and architecture. Streamline Moderne was all the rage, with simplified lines that emphasized the horizontal, curves, and speedlines punctuated by unexpected height from pylons. Fads don't change overnight, however, and both styles were used throughout the 1920s and 1930s, and new buildings featuring elements of each were constructed for several more decades.

Other factors, though perhaps less dramatic, shaped Long Beach as well. There were film studios, oil wells, and, of course, the beach and harbor. The area was originally part of the Rancho Los Cerritos land grant that was incorporated in 1888 and named for its long, wide beaches. Railroads brought visitors to Long Beach, creating a real-estate boom. In 1911, the port was established, which is now the busiest in the United States.

Long Beach has always been a tourist attraction. The Pike, opened in 1902, quickly became one of the most popular amusement parks on the West Coast. Bathing beauties could rent swimsuits to enjoy the ocean or a heated indoor plunge. A carousel, roller coasters, restaurants, shops, ballrooms, and vaudeville shows increased their enjoyment. The Pike's most famous roller coaster, the 1930 "Cyclone Racer," stopped running in 1968, the year after the city's current Deco attraction, the Cunard steamship *Queen Mary*, steamed into port on her final voyage. The Pike, deteriorated after years of neglect, was completely demolished; the *Queen Mary*, although in perpetual jeopardy of being sold or scrapped, still resides grandly in the harbor.

In the 1970s and 1980s, a plague of urban development cleaned up the city by replacing post-earthquake structures with glass and steel boxes. In spite of all the buildings lost, however, Long Beach still retains a fine selection of Art Deco buildings and murals. Some are pristine, while others are run-down or "remuddled." Look around. This book lists only a few, and many more are waiting to be discovered by a discerning eye. Enjoy the exploration.

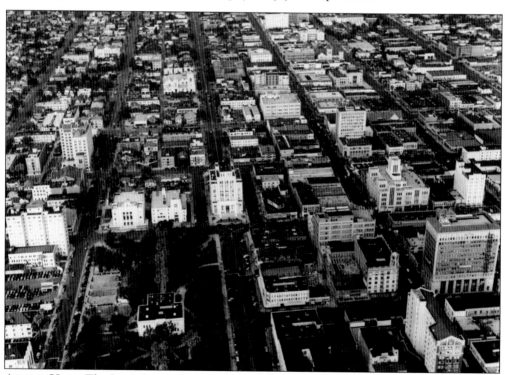

AERIAL VIEW. The Long Beach skyline changed dramatically during the Deco years. A 1923 headline about new construction in the beach city declares, "Tall Buildings Become a Habit." This aerial view shows downtown looking north from Lincoln Park, from Chestnut to Pine. (Courtesy Long Beach Public Library.)

One

COMMERCIAL BUILDINGS
THE NEWEST AND BEST

Because of the unique factors that shaped the history of Long Beach, the city has a plethora of commercial buildings from the 1920s and 1930s. Long Beach grew rapidly in the early part of the century, and the businesses that sprang up to meet the growth sought to capture the eye of a customer with the newest and best. Zigzag Moderne was a style that grew out of *L'Exposition Internationale des Arts Décoratifs et Industriels Modernes*, a 1925 showcase for modern design held in Paris. The 1920s were exuberant, as the "war to end all wars" was over and World War II was not yet on the horizon. The styles coming out of *L'Exposition* reflected that optimism. Large or small, buildings stood straight and tall with decorative towers and setbacks, buoyantly ornamented with zigzags and flourishes. The other factor that shaped Long Beach architecture was the earthquake. Occurring in 1933, just as styles were changing in response to the Depression, Streamline Moderne featured sleekly simplified lines and an almost nautical styling. It is not unusual in Long Beach to find buildings, especially small businesses, with a Streamline Moderne facade added to an older structure. In many cases, only the front crumbled when the earth shook, leaving the sides and rear intact and the facade ripe for modernization.

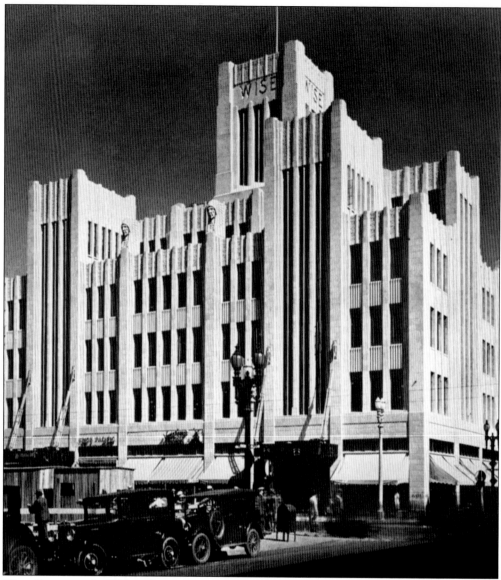

WISE COMPANY. In 1929, architect W. Horace Austin asserted that about $1.65 million would be required to "cover cost of land and improvement" for the building planned for the Wise Company at the corner of Pine Avenue and Broadway. In 1933, the department store was among the first to reopen after the quake. In 1964, the construction was lauded as surpassing "the current structural demands required" when it was announced that "with the exception of the concrete frame the building will be totally new," with "aluminum window-walls" replacing the terra-cotta skin. Thus this building is still technically here, but one certainly could not tell by looking at it. (Courtesy Long Beach Public Library.)

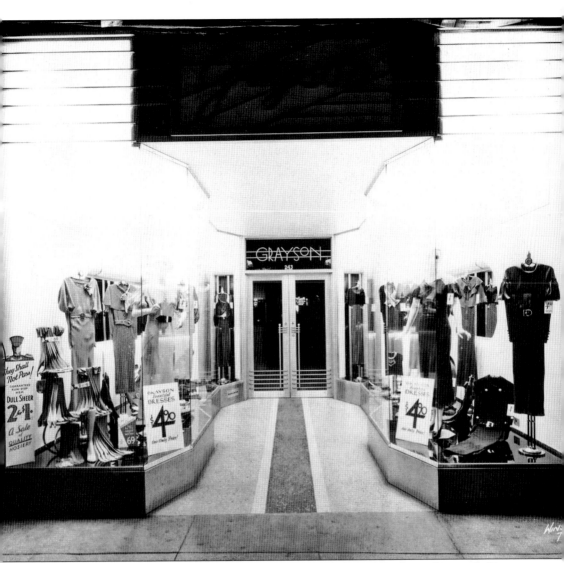

GRAYSON'S. When Grayson's opened a Los Angeles store in 1932, they advertised, "A new dress shop . . . dedicated to those women who prefer quality within reason rather than economy without reason." They had only two price groups at the time, $4.90 and $8.90. A few years later, their 1938 "Bolero Frocks" had "that $25 look" but cost only $6.99. Their Long Beach store was as elegant as the women who shopped there, with a terrazzo entrance between show windows and doors replete with speedlines. The dresses in the window have elaborate puffed sleeves and sleek, bias cut hips. This look typified the early to mid-1930s; the shoulders, made more prominent with sleeve detailing, presaged the wide shoulder pads that came into fashion shortly thereafter. (Courtesy Long Beach Public Library.)

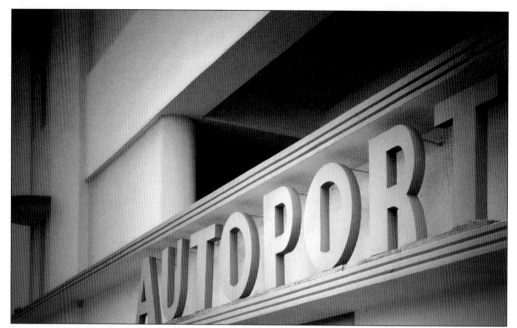

BUFFUMS AUTOPORT. Charles A. Buffum was mayor of Long Beach from 1921 to 1924. He was well known in the city as the cofounder with his brother, E. E. Buffum, of the store that bore their name. The store was demolished in 1980. The sign, designed by A. R. Bradner in 1940, directing customers to the all-important parking lot, is all that remains at 119–121 West First Street.

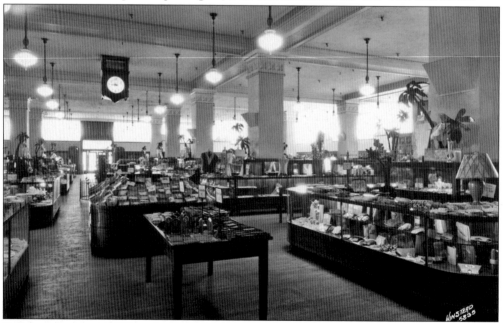

BUFFUMS INTERIOR. When the Buffum brothers' six-story addition opened in 1924, it was said, "The new store has been built entirely with an eye to the future needs of Long Beach" rather than a present need for more room. Besides the tables and showcases, pictured around 1929, the store had a beauty shop, travel agency, post office, and fur-storage vaults. (Courtesy Long Beach Public Library.)

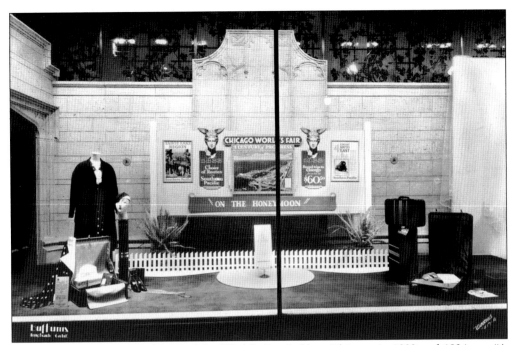

BUFFUMS WINDOW. The theme of the World's Fair held in Chicago in 1933 and 1934 was "A Century of Progress." The organizers intended the focus to be on science, but retailers had a different idea. It would appear, with the modern world's focus on how science can be used to make a buck (or two or three billion), they were both right. (Courtesy Long Beach Public Library.)

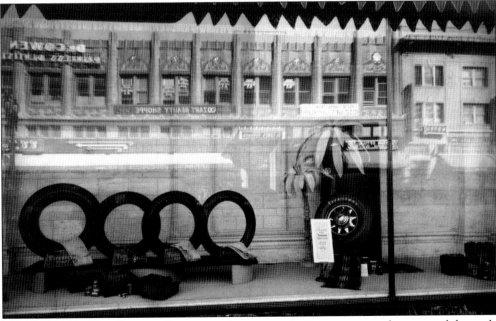

BUFFUMS WINDOW (ROWAN BUILDING REFLECTION). Bringing several aspects of the early 20th century together, this 1934 photograph displays tires and automobile accessories while reflecting the glorious terra-cotta tile of the Rowan Building across the street. (Courtesy Long Beach Public Library.)

13

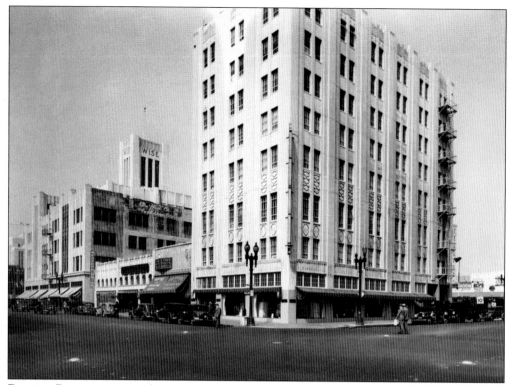

BARKER BROTHERS. An admiring *Los Angeles Times* lauded the Dedrick and Bobbe design at 215 Promenade Plaza as reinforced concrete "with all the latest protective and fireproof devices" in 1929. The basement and eight floors were devoted to selling "pianos and radios, living-room, dining-room and bedroom furniture, floor coverings and draperies" and accessories galore. Because it did not meet seismic ordinance, the owners demolished it in 1994. (Courtesy Long Beach Public Library.)

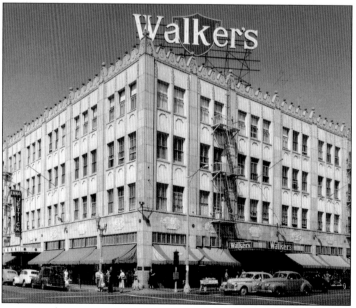

WALKER'S DEPARTMENT STORE. In 1933, Mayor Paddock presided at the grand opening of Walker's Department Store at 401–423 Pine Avenue; 5,000 roses were to be given away as souvenirs. Meyer and Holler designed the store in 1928. Owner Ralf Marc Walker was known as a philanthropist, and his obituary mentioned his interest in developing character and financial success among the young men and women who worked for him. (Courtesy Stan Poe.)

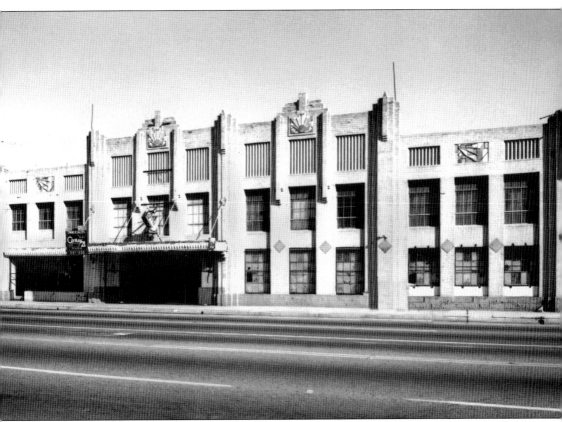

278 ALAMITOS AVENUE. Originally built as an auditorium and skating rink in 1930, the building permit lists Charles R. Butler as the owner but does not mention whether or not he was the same man who was instrumental in developing the Signal Hill oil industry. Skating was a popular form of entertainment during the period, and many cities built rinks for both ice and roller skating. Sonja Henie's medals in three Olympics, parlayed by the bubbly blonde into a successful film career, certainly didn't hurt the popularity of the sport. It was a source of humor as well. One cartoon from *Punch* in 1930 shows men and women lounging on a beach, with the title, "After halcyon days of enervating ease," followed by the same people, in the same poses, fallen on the ice and the caption, "Oh, what an enervating change!" Another stars a young lady who blames her poor skating performance on her lack of a proper costume, proving perhaps that the clothes make the skater. (Courtesy Stan Poe.)

FAMOUS DEPARTMENT STORE. Morgan, Walls and Clements created many of the iconic buildings in Los Angeles, including the Wiltern Theatre, Samson Tire Factory (now the Citadel Outlets), and the black and gold terra-cotta Richfield Building, which is still mourned by preservationists. In 1929, they designed a building at 601–609 Pine Avenue for Famous Department Stores. A 1938 top-floor addition integrates well with the older structure, now occupied by Rite-Aid.

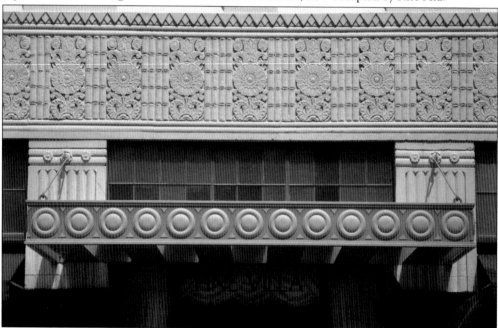

117 EAST EIGHTH STREET. The Long Beach Professional Building was the first large building in the city devoted to medical offices. Built for W. Patton Wilson, the eight-story building provided accommodations for 6 stores and 150 offices. The *Los Angeles Times* mentioned in 1926 that Dedrick and Bobbe had prepared plans; in 1930 they ascribed a medical-dental building on the corner of Pine Avenue and Broadway to Walker and Eisen.

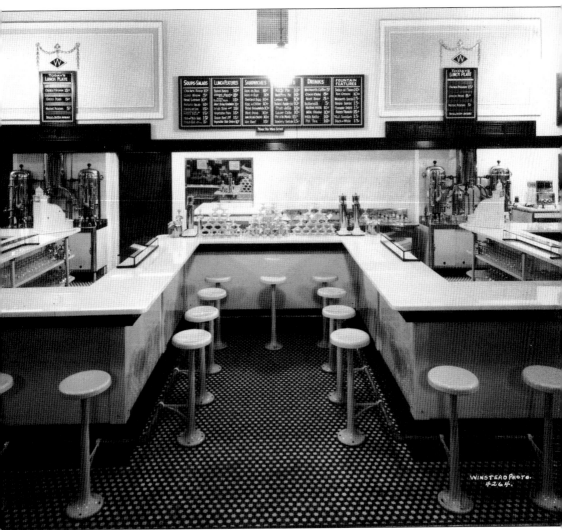

WOOLWORTH'S LUNCH COUNTER. Where better to find "a million dollar baby" than, as the song says, "in a five and ten cent store"? Woolworth's lunch counter was the precursor to the modern teenage girl's "I'll meet you at the mall food court, okay?" F. W. Woolworth was one of the first to put merchandise out for the client to handle and examine, rather than making a customer wait for a salesclerk to bring it out from behind the counter or a stockroom in the back. The store sold basic merchandise, everything from spatulas to parakeets, at a fixed price of 5¢ to 10¢. A quote from the founder said, "I am the world's worst salesman, therefore, I must make it easy for people to buy." He did just that, since Woolworth stores could be found on every Main Street in every town. This one in Long Beach was located at 335 Pine Avenue; the photograph shows the *c.* 1927 menu. (Courtesy Long Beach Public Library.)

INSURANCE EXCHANGE BUILDING. In order to accommodate a need for space for the small claims and superior courts, businessmen Way and Lorne Middough agreed to raise the height of the clothing store they were erecting at 126 East Broadway in 1925. Until the courts moved to the Jergins Trust Building in the late 1920s, criminal cases were heard on the sixth floor; the ground floor housed The Boys Shop. In this security-conscious age, the idea of a court with potentially dangerous criminals a few floors above mothers shopping for school clothes with their sons sounds decidedly odd, but Long Beach was a much smaller town then. The Harvey H. Lockridge designed building, with bas-reliefs of children's sports, was sold in 1931 and became the Insurance and Exchange Building. During World War II, it was used as a troop mess hall. Lorne Middough became a Democratic congressman, serving from 1938 to 1946.

236 WEST THIRD STREET. In September 1928, Col. Ira C. Copley announced from his yacht, *Happy Days*, that he was adding the *Long Beach Sun* to his 23 Southern California newspapers. He had his staff architect, Francis D. Rutherford, draw up plans for a building to house the presses, editors, photographers, newsboys, and reporters. By 1932, he sold the *Sun*, leaving this Spanish-influenced building for posterity.

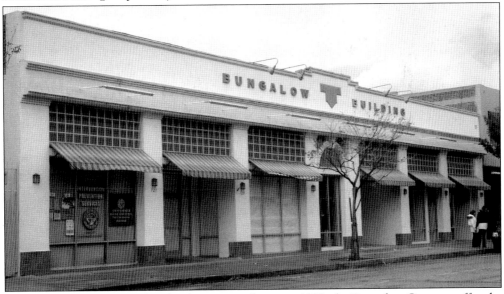

727–735 PINE AVENUE. Shortly after its completion in 1922, the Bungalow Grocery suffered a devastating fire. At the time, it was considered a large shopping center, and the *Los Angeles Times* reported, "every downtown fire-station crew and apparatus was engaged for five hours combating the blaze." George W. Kahrs altered the storefront in 1941. More alterations were done in 1967, but the building retains a modest 1920s charm.

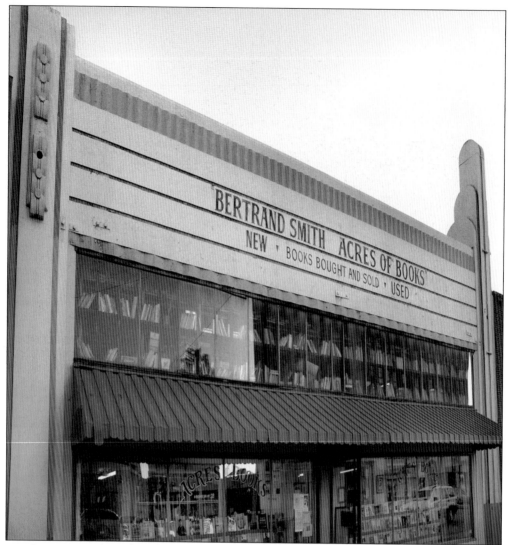

240 SOUTH LONG BEACH BOULEVARD. Earthquake damage precipitated a 1936 remodel in which a 1920s market became the Glenn E. Thomas Used Car Store. In 1938, a gadfly taxpayer sued the mayor and eight members of the city council over cars bought there. His complaint was based on the fact that Eaton was an employee and stockholder in the Thomas Company at the time of purchase. The lawsuit took on political ramifications when the Democratic Central Committee declared that it "may result in preventing Mayor Eaton from being seated in Congress." It didn't, and he served until his death in 1939. Since 1964, the building has housed Acres of Books, a beloved Long Beach used bookstore founded by Bertrand L. Smith in 1936. It is currently in danger of demolition.

445 EAST FIRST STREET. The 1924 building permit for this charming structure, with the main entry set diagonally to the corner, is missing, but it is known that in 1948 architect Hugh Gibbs added a drafting room; by 1962, if not earlier, he owned the building. In the late 1940s, Gibbs was making a name for himself designing moderately priced housing tracts. A 1947 advertisement describes a tree-covered planned community where a home wouldn't "use all your G.I. loan." Interestingly enough, Schilling and Schilling located their offices on this corner after the earthquake. This was quite a heady architectural pedigree for a relatively small building. In 1929, C. C. Adamson Photography was also in residence there. The detail seen here is placed over the corner door.

MERRILL BUILDING. Following the 1933 earthquake, $6,000 and Schilling and Schilling were able to transform a c. 1921 building at 810–812 North Long Beach Boulevard into a significant example of Zigzag Moderne. A patterned frieze surmounts ground-floor storefronts, once occupied by K. C. Welch's butcher equipment and the E. A. Glass restaurant. Tenants of the upper floors, under the incised title, "Merrill," included the Long Beach Nurse's Institute.

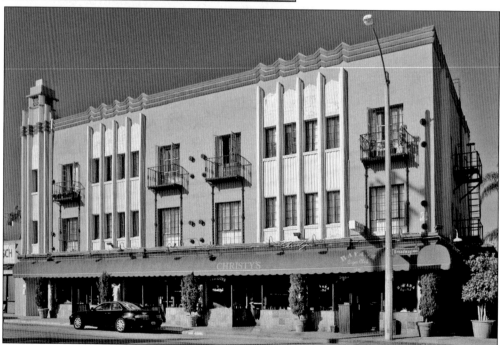

3937 EAST BROADWAY. Built in 1929 for Wiese and Wiese, this building with both apartments and retail space seems to be raising decorative eyebrows at the world. The design is attributed to architect Edwall J. Baume. The Broadview Market occupied the ground floor around 1930, while the upstairs apartments saw their share of wedding announcements throughout the 1940s.

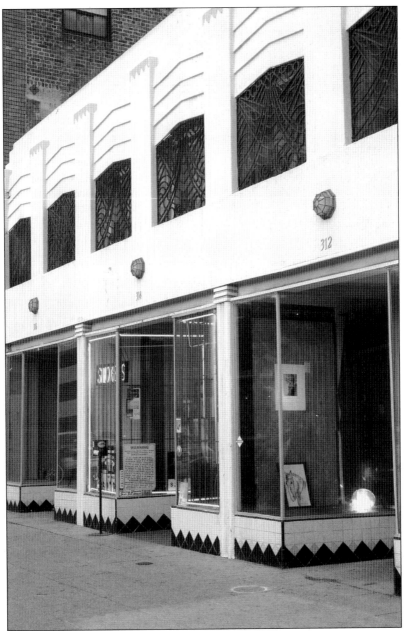

312–316 ELM AVENUE. This superb example of small-scale Art Deco architecture by George D. Riddle is one of the lucky few to be preserved intact. The tile echoes chevrons over the windows, forming stylized waves that seem particularly appropriate for a beach city. Second-story windows retain elaborate metal grilles. During World War II, Riddle was the Federal Housing Administration's chief architect. Obtaining building materials was a challenge during the war years and at a conference where Riddle spoke it was recommended that those who get hold of materials take delivery immediately "and keep the stuff in your backyard with a watchman." Construction was done by J. D. Sherer and Son, who worked on schools and public buildings throughout Long Beach and Orange County. In 1930, the new building would have been surrounded by similar designs. Today it is a designated historic landmark.

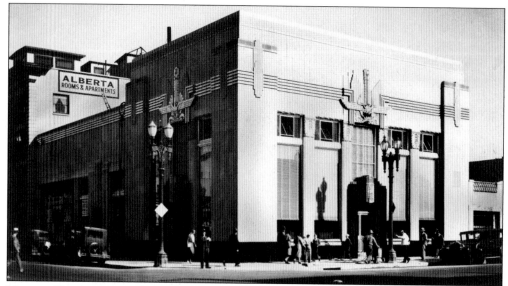

MUTUAL BUILDING AND LOAN. In 1959, the Alexander Hotel Company owned this property; no earlier building permits have been found. Scott Alexander, a civic leader who died in 1926, was instrumental in building the Alexander Hotel and in the fight for municipal gas and development of the harbor, including reclamation of beach frontage as a site for the Municipal Auditorium. (Courtesy Long Beach Public Library.)

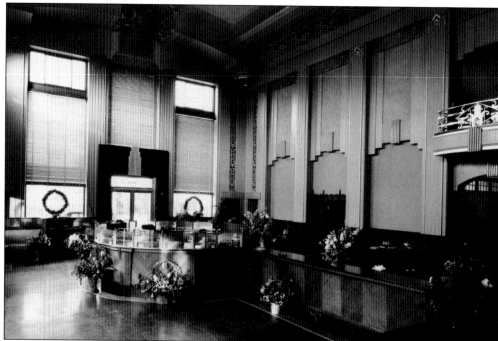

MUTUAL BUILDING AND LOAN. Not only was the building style quite modern, or perhaps Moderne, but Mutual Building and Loan of Long Beach was progressive enough to appoint a woman as vice president in 1921. Margaret N. Stevens was promoted from assistant secretary upon the death of her father. This interior view of the building, formerly at First Street and Locust Avenue, is from around 1931. (Courtesy Long Beach Public Library.)

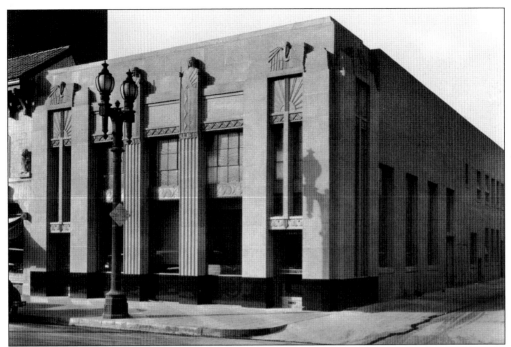

215 EAST BROADWAY. This was certainly a sweet building when Albert Sheetz sold candy here in 1929, around the time this image was taken. Sunbursts topped the windows, and bas-relief guardians perched atop fluted pilasters. When a plate-glass show window was added in 1940, it was a dress shop. The rest of its stories are lost to time . . . (Courtesy Long Beach Public Library.)

215 EAST BROADWAY. . . . as is the front of the building. The side, on the other hand, with its sunburst pattern still visible, retains its Deco heritage.

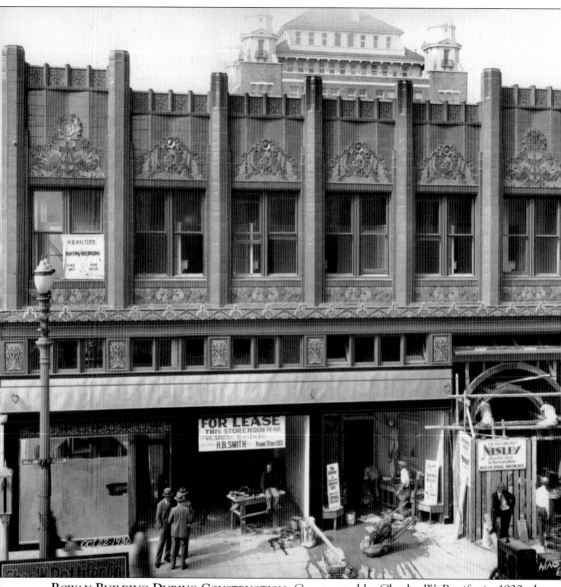

ROWAN BUILDING DURING CONSTRUCTION. Constructed by Charles W. Pettifer in 1930, the building at 201–209 Pine Avenue takes its name from an early tenant. Dr. Rowan or Cowan (the records contradict each other) was a dentist who advertised that his dentures were less expensive than a pair of women's high heels from the exclusive Nisley Shoes located in the same building. A theft from the shoe store's safe in 1934 was staged as a break-in, with a broken transom and chair arranged to give the impression that the thieves had entered from the outside. Police, however, noticed that the dust on the transom was undisturbed and concentrated their investigation on employees. Other tenants included Patsy Frocks in the corner store and Hal Ash Limited, Millinery. It seems to have been tailor-made for a fashionable lady who wanted to amuse herself by shopping for a whole new wardrobe while her husband had his teeth cleaned. (Courtesy Stan Poe.)

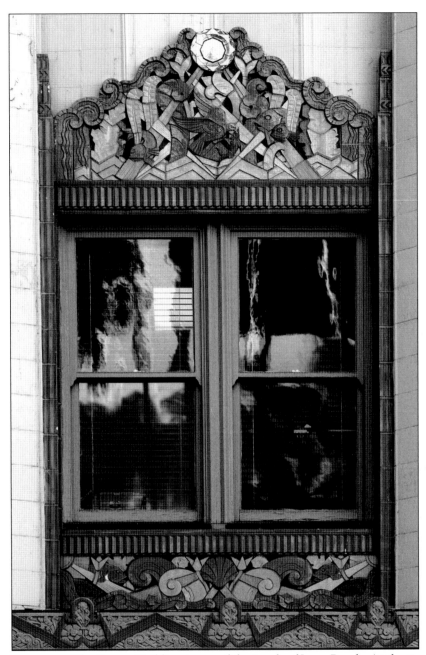

ROWAN BUILDING. The Rowan Building is one of the jewels of Long Beach. At the time it was constructed, the building was one of several near the corner of Pine Avenue and Broadway that were sheathed in terra-cotta tile. The Rowan Building is the only one still reasonably intact. Constructed for Bank of Italy (later the Bank of America) in 1930, the upper story features the most exuberant tile in the city in a rainbow of brilliant colors that include purple, gold, gray, turquoise, and tan. The sign for *Birdland*, a jazz club that was a one-time tenant, seemed to describe the tiles with their seaside motif of brightly colored birds fluttering under a golden sun over stylized waves, dancing with fish. Other abundant motifs include seashells, flowers, kelp, and geometric patterns in blithe abandon.

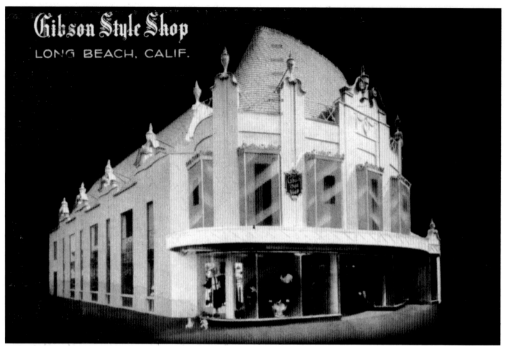

GIBSON STYLE SHOP. The Gibson Style Shop, formerly at 501 East Ocean Boulevard, looks like a Deco dream; the Regency Revival style with its urn-topped pylons is as fanciful as a S. Charles Lee theatre. Established in 1926, the shop showcased women's clothes until it fell to the bulldozers. (Postcard uncredited.)

5390 NORTH LONG BEACH BOULEVARD. O. S. Peterson owned this storefront in 1939, but he had been selling major appliances for years. A 1925 advertisement showed the lady of the house happily carrying her golf clubs to the car because "Maytag washers take the hard work out of washday." Kelvinator refrigerators took center stage in 1932, followed by "family size" General Electric refrigerators freezing 80 cubes of ice silently and thriftily in the early 1940s.

5350 North Long Beach Boulevard. Built as a store in 1934 for A. L. Jones, this structure displays a fine zigzag roofline with fluted pilasters acting as bookends. Jones Department Store sold blankets, girdles, and children's sleepers from this location until at least the late 1950s. Adaptive reuse has turned it into a church.

2101 North Pacific Avenue. Since Rexall Drugs was a prominent name during the Deco era, one would think there would be more history on this store. The architectural record, however, only goes back to 1949, when the canopy was added. It would appear that the ground level has been severely altered sometime between the 1950s and 1970s, but the diamond-patterned piers on the upper story are most certainly older.

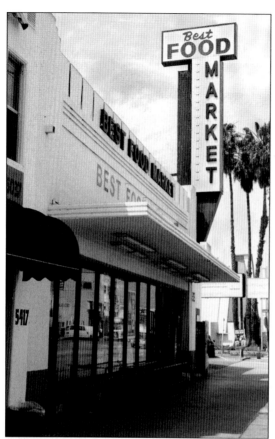

5425 NORTH LONG BEACH BOULEVARD. This market was built in 1941 for Safeway Stores. In 1936, the Safeway Employees' Association celebrated their first anniversary with a cake large enough to serve 2,000 at a dance in their club rooms in Los Angeles. The group had a membership of more than 18,000 employees from Los Angeles, Pasadena, Long Beach, and the San Fernando Valley.

2234–2240 EAST FOURTH STREET. E. A. Renfro chose Wesco Construction Company to work on this storefront, once occupied by W. R. Clemens Meats, in 1933. Wesco was a prominent construction company, hired throughout Southern California. In 1936, their workers laid down their tools in several strikes, with skilled workmen supporting unskilled labor in their demands for a wage of 60¢ an hour to erect the Ventura Post Office.

3232 EAST BROADWAY. Building permits leave so many questions unanswered. In November 1924, Cora and Clara Whipple received approval for lathing on four-family flats., though it is unclear whether Cora and Clara were lace-clad old ladies or racy flapper sisters. The building itself bears traces of its Deco origins but nothing of the women who built it.

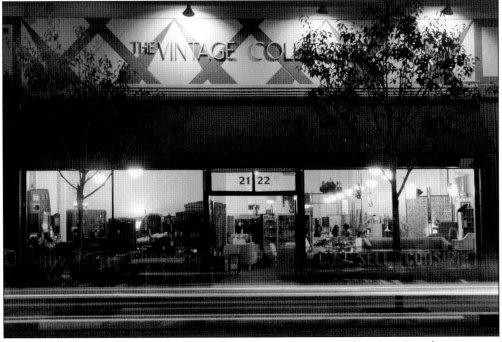

2122 EAST FOURTH STREET. This storefront was built in 1930 for a Los Angeles company, M. R. and W. Development; Fuller and Mellon were the contractors. In 1948, Acme Furniture Company auctioned off furnishings, rugs, and appliances there. The building, with an incised mural that with a few simple strokes conjures up an image of klieg lights at a movie premiere, now sells antiques and collectibles.

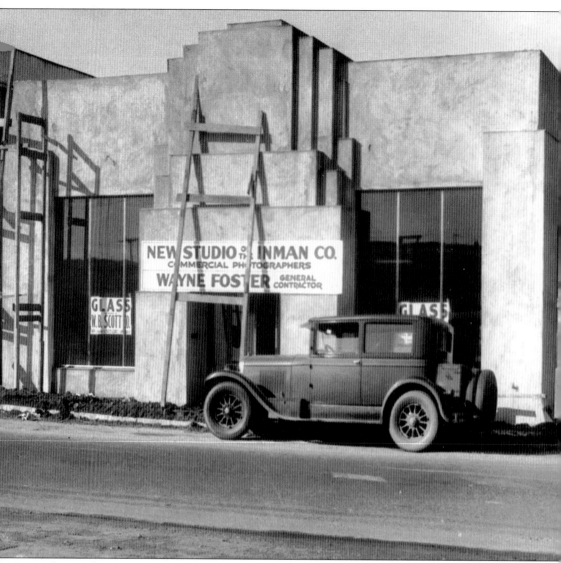

INMAN STUDIO. Lawrence Inman was a prominent photographer in Long Beach during the early 20th century. His studio at 2491 North Long Beach Boulevard was constructed in 1931 by contractor Wayne Foster. In 1928, Inman was part of a good-will expedition designed to promote the Pacific Southwest Exposition. Their plane was to circle a number of California cities, scattering greetings and complimentary tickets before landing. Inman photographed Long Beach extensively, and his photographs still appear on old postcards, newspaper clippings, and books like this. The postcard of the Munholland Apartments is one of his photographs, as are many from the Historical Society of Long Beach. Even in its unfinished state, the ziggurat over the door to his studio shows his appreciation of Art Deco architecture—although he would have described it merely as modern, as the term Art Deco wasn't coined for nearly 40 more years. (Courtesy Stan Poe.)

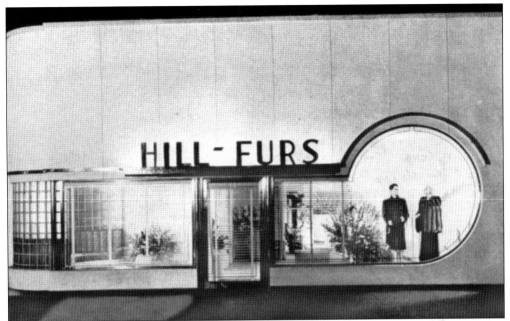

HILL FURS. During the 1920s and 1930s, no movie star or socialite would be seen in a coat that wasn't luxuriant fur. Women who never appeared in either a social or gossip column craved fur as well. Hill Furs, located at 3316 East Broadway, catered to their desires from a storefront featuring glass brick and a circular display window. (Courtesy John Parker family.)

862 NORTH ATLANTIC AVENUE. A charming but anonymous little building displays waves along the roofline and stepped, fluted pilasters. All it needs are candles on top to look like a birthday cake. It was looking for a tenant in 1930—a bakery would have been appropriate.

HANCOCK MOTORS. A true Deco gem, this 1928 building at 500 East Anaheim Boulevard has it all: bays of plate-glass windows, floral and geometric motifs, stylized rams' heads at the corners, original Art Deco chandeliers, and an impeccable architectural pedigree. Schilling and Schilling, who designed the Lafayette Hotel as well as other Long Beach icons, was among the most important local architectural firms; Cecil Schilling was president of the Long Beach Architectural Club. Consulting architect W. Horace Austin was equally eminent. This Long Beach Historical Landmark originally sold Hupmobiles, a car the average working man could afford that was noted for reliability and endurance.

HANCOCK MOTORS CHANDELIER. Guests danced under the geometric chandeliers on October 27, 1928, at the party celebrating the opening of the new Hancock Motors Building. A man in top hat and tails, hired by Lemuel A. Hancock for the occasion, greeted them at the door. The cars were elegantly spotlighted, with salesmen in tuxedos there to help should a guest happen to want more information about the Hupmobile.

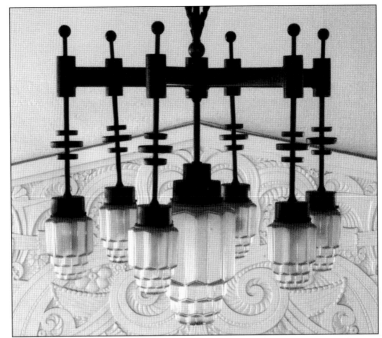

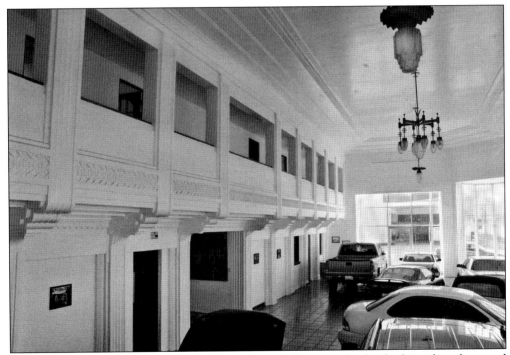

HANCOCK MOTORS INTERIOR. The building is beautifully restored today, both inside and out, and is one of the real success stories of preservation in Long Beach. The balconies are as handsome as they were when local dignitaries stood there to speak to the opening-day crowd. The cars have changed, but the building remains the same.

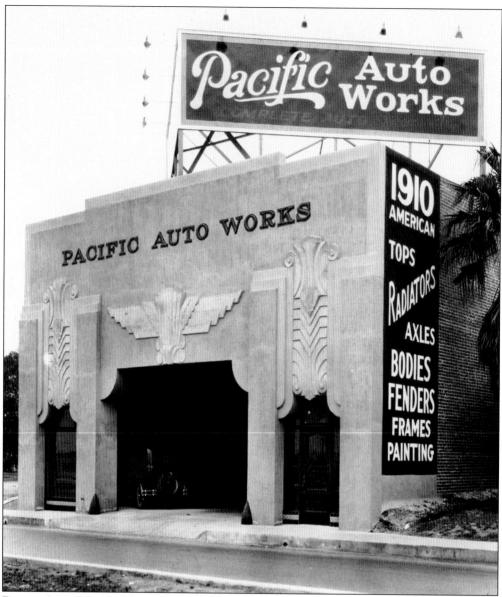

PACIFIC AUTO WORKS. This is more proof that the automobile had a huge influence on architecture in the 1920s, and that some of the finest structures were built to sell or repair cars or just to attract the attention of a passing motorist. Pacific Auto Works Complete Auto Reconstruction was designed in 1928 by Schilling and Schilling. The door and windows were evocative of theatre curtains slowly opening, with autos taking center stage. The oversized ornamentation increased the drama. The salmon-colored cement and stucco facade had tile under the doorways. The sides, however, were brick. Before its demolition it was located at 1910 American Avenue, which is now Long Beach Boulevard. (Courtesy Historical Society of Long Beach.)

233 East Anaheim Street. The Deco period was certainly the heyday of the pylon. This one looks like it could adorn a theatre but, instead, draws attention to a body shop. In 1946, neon signs announcing "United Service Motors," "U.S. Tires," and "Batteries—Carburetor— Ignition" were added.

500 West Anaheim Street. The details on this building, once owned by Shell Oil, are poured-in-place concrete. It was a popular way to decorate buildings, providing elaborate designs as part of the structure rather than an added-on decoration. A plaster mold was created and filled with concrete as part of the building process. When it hardened, it was an integral part of the wall.

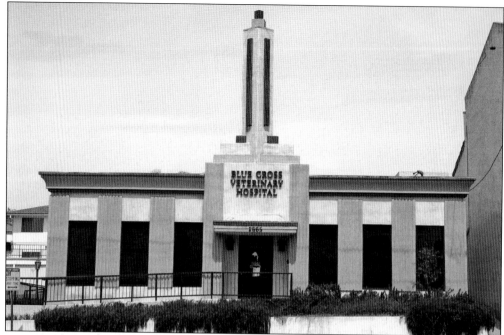

2665 EAST PACIFIC COAST HIGHWAY. In a fine example of adaptive reuse, this building now houses a veterinary hospital. Perhaps they should take it a step further and add a Deco dog to the top of the pylon.

3419–3425 NORTH ORANGE AVENUE. Rex L. Hodges Realty opened in 1929 when "most businesses were closing and this didn't seem like the proper time to start a new venture," but, as the *Los Angeles Times* writer then admitted, the company flourished. In 1940, Hodges added a garage and altered the front of this building, but it retains its *c.* 1924 tile and an eye-catching pylon.

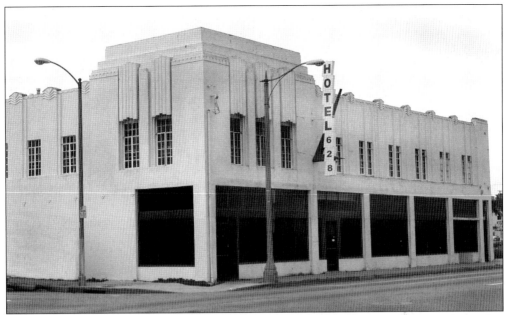

620–628 East Anaheim Street. Hancock Brothers had an electric plating works in this building in 1933. J. E. Burrell was the contractor who rebuilt it following the quake. He also had the contract for Jane Addams Elementary School and the California National Guard Armory. It was still a factory in 1938 but has now been adapted for use as a hotel.

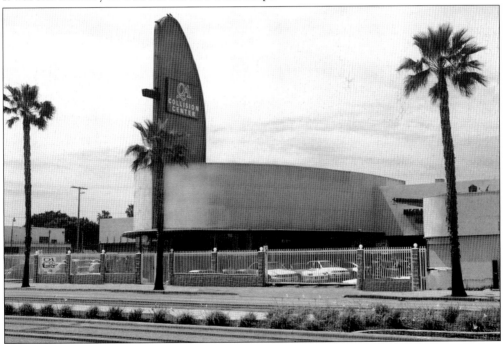

1427 North Long Beach Boulevard. Although the original 1928 structure was called an "auto shed," when architect Hugh Davies made several additions and changes throughout the 1940s, the company was described as either a Packard dealer or by the anonymous title of "garage." Business must have been booming, for each addition increased the square footage.

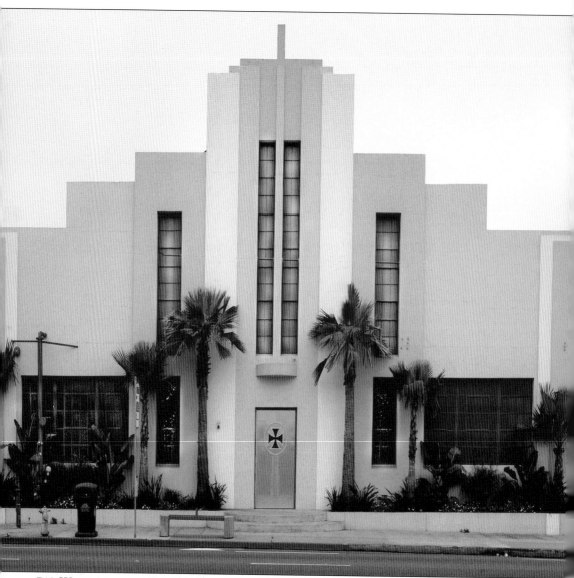

718 WEST ANAHEIM STREET. From "cleanliness is next to godliness" to bikers who don't mind grease under their fingernails, with a colorful history in between, this building has seen it all. In the early 1920s, it housed the Soft Water Laundry. Physical evidence suggests that a new facade was added after the quake, but no building records have been found for confirmation. In 1952, architect Kenneth S. Wing, who designed the airport terminal, added a sales room, sign structures, and a canopy over the entrance. At one time, at least part of the building was the factory and store of Ellis Paint Company, a family owned business founded in Montana in 1887 that moved to Long Beach in the early 1930s. This striking and beautifully restored building is currently the home of West Coast Chopper, a company that specializes in custom motorcycles and accessories.

Two

RESIDENTIAL
HOME SWEET DECO

Most people, when they sink their hard-earned savings into a dream house, want a place that feels warm and comfortable. Deco may have struck people as too cold, or perhaps just too cutting edge during its time, to want to come home to after a hard day at the office. Far more residences of the time were built in traditional styles like Spanish Revival, Tudor, Craftsman, or Mediterranean. A few brave souls, however, embraced the dramatic new style. One finds both apartments and hotels in Streamline and Zigzag Moderne, but even there Revival styles, sometimes called Classical Deco, were popular. Frequently the details on even the most traditional of buildings will betray its origins with a geometric relief panel typical of the 1920s or speedlines evoking the 1930s. One unfortunate fact of historic research in Long Beach is that throughout most of its history the city didn't require an architect's name on the building permits, so virtually every building that was too small to be considered newsworthy was anonymous. Sometimes traces can be found of the people whose lives and work shaped the building's function but only rarely the name of the person who created the building's form.

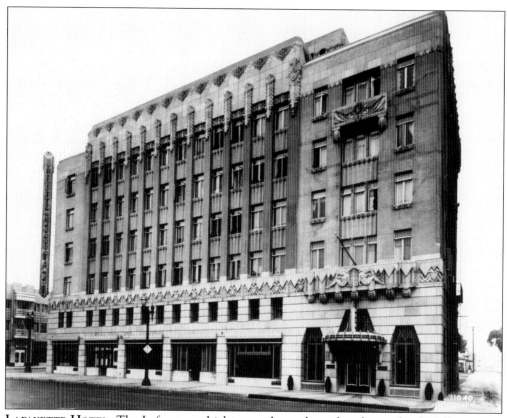

LAFAYETTE HOTEL. The Lafayette, which opened two days after the crash of Wall Street in 1929, housed the elite of Long Beach. Decorative elements of Cecil and Arthur Schilling's design include zigzags, stylized leaves, and a ram's head with hanging garlands modeled after one used at the Paris Exhibition. (Courtesy Long Beach Public Library.)

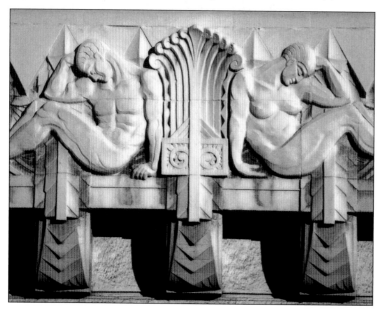

LAFAYETTE HOTEL DETAIL. Had Michelangelo lived in the late 1920s, his figures for the Medici tomb, with *Night* represented by a woman and *Day* as a man, may have had this flat, stylized look. This age is lucky enough to still have the Renaissance masterpiece, as well as the Lafayette Hotel, a Deco masterpiece with figures over the door inspired by Michelangelo.

Lafayette Hotel Hall. A 1930 article about the hotel enthused, "Modern architecture modified to present a pleasing smoothness of line is enhanced by furnishings reflecting beauty and luxury." Men in the late 1950s would agree about the beauty being reflected when the hotel was the home base for contestants in the Miss Universe pageant. (Courtesy Long Beach Public Library.)

Lafayette Hotel Restaurant. Diners no doubt appreciated the hotel restaurant, although no one in this 1931 photograph seems particularly happy. Perhaps someone told them that the Santa Claus in the background was only carrying lumps of coal. The society columns certainly raved about the hotel. It was said that the Lafayette "reflects the last word in catering to the comfort and convenience of guests." (Courtesy Long Beach Public Library.)

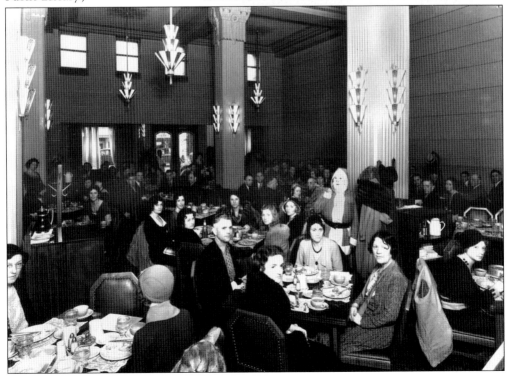

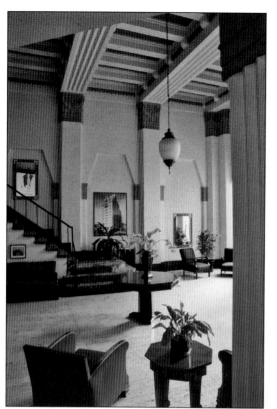

LAFAYETTE HOTEL LOBBY. The Lafayette Hotel is now a condominium complex with shops and galleries sharing the ground floor. An effort has been made to retain the historical charm, much to the delight of preservationists and residents. It is located at 140 Linden Avenue. Although the furniture in the lobby is modern, it is perfectly in keeping with the original architecture.

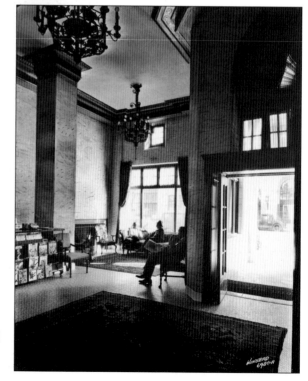

THE RITZ HOTEL. There are no traces left of the Ritz Hotel at 154 Elm Avenue. In 1930, however, the lobby was typical of the hotels of the period with elaborate chandeliers and tile floors. (Courtesy Long Beach Public Library.)

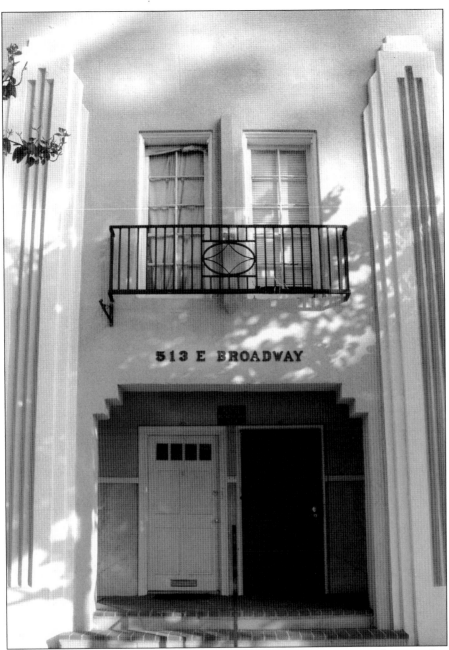

513 EAST BROADWAY. So often what we know of history deals with crime, violence, and suicide. This peaceful-looking dwelling was built in 1922 by W. P. Campbell, who lived in an apartment there and, per the *Los Angeles Times*, was "regarded as wealthy." In 1924, he was reported missing. He was found at the home of his brother-in-law, where his daughter struggled to get a gun away from him. Her screams roused the neighborhood, and when she went to open the door for the police, he took advantage of the opportunity and pulled the trigger. The home he built has decorative stair-stepped pilasters flanking the entry, which is cut in a simplified ziggurat shape, drawing the eye past the windows to visually increase the height of the two-story building. He also owned the Metropolitan Apartments at 505 East Broadway.

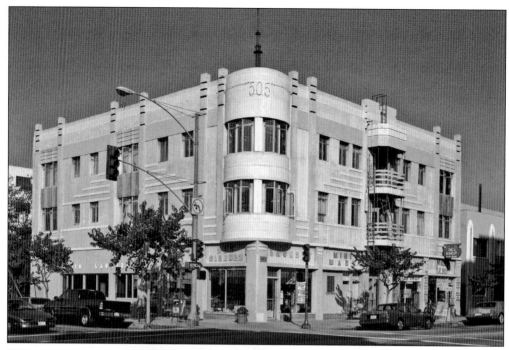

METROPOLITAN APARTMENTS.
The building at 505 East Broadway was constructed in 1922 for W. P. Campbell, the same year he built the apartments just down the street that were his home. The ground floor housed a market with apartments upstairs. In 1933, the building took on the elegant silhouette with curves and speedlines seen here.

1227 EAST OCEAN BOULEVARD.
The Regent Apartments seem to have been rather exclusive, as several people who lived there were described with adjectives such as "wealthy" or "oil man." Anything to do with the automobile was good for business in the 1920s and 1930s, be it oil, tires, or a building designed to stop traffic.

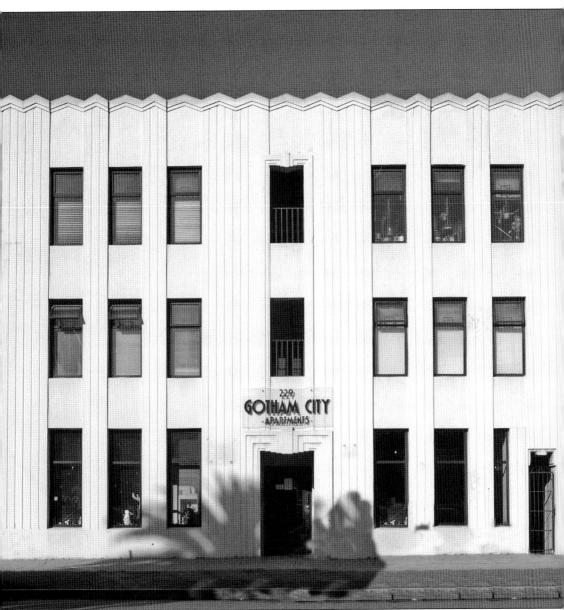

229 ATLANTIC AVENUE. Built in 1928 and repaired in 1933, the Gotham City Apartments building looks like it could figure in a dramatic scene of a movie. It even provides its own story line. In 1937, a forger "trapped himself like a novice," according to the *Los Angeles Times*, by returning to one of his victims and trying to pass another bad check. James Fulton would rent an apartment, write a false check for sums above the amount charged for rent, take the rest in cash, and then disappear. Building owner B. O. Sheppard recognized the culprit when he wrote a $75 check and asked for change. He called the police, to whom the forger made a complete confession.

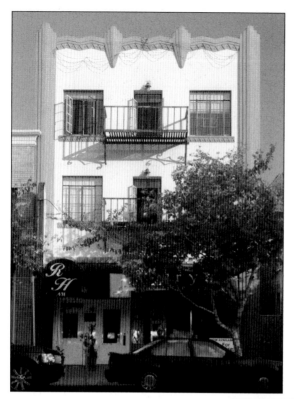

431 EAST BROADWAY. No doubt many people chose to make the *c.* 1924 Royal Hotel, with its wedding-cake trim, their home, but only one tenant made the news in 1943 when she was found nude on her couch, unconscious from a malfunctioning heater spewing carbon monoxide. A post-quake building permit mentions owner Mrs. John Krick, most likely the same lady who adorned social columns with her gorgeous, blonde daughter throughout the 1930s.

304 WEST ANAHEIM STREET. It was said that a lady's name should be in the newspaper only three times: at her birth, her marriage, and her death. This lovely structure must have been a hotbed of bridal dreams and wedding plans in the late 1930s and early 1940s as it figured frequently in columns entitled "Intention to Marry." Most of the women became navy wives.

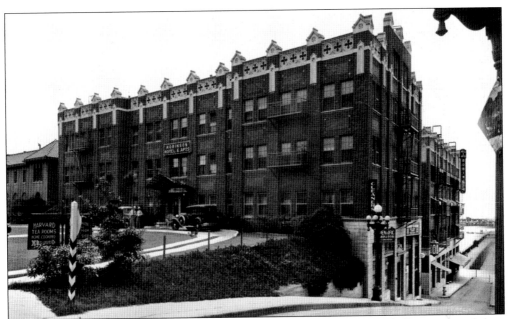

ROBINSON HOTEL (PRE-QUAKE). In late 1932, the Hollywood Stars baseball team moved their training camp to Long Beach. They were living in the Robinson Hotel when the quake hit. Although the only injury was a bruised foot, the next day they moved again . . . to the wide, open spaces of West Los Angeles. (Courtesy Long Beach Public Library.)

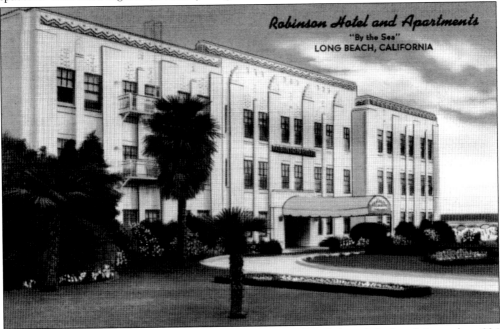

ROBINSON HOTEL. Contractor John W. Flanagan repaired and altered the hotel, formerly at 334 West Ocean Boulevard, in August 1933. In 1954, a couple who summered in Long Beach for years before making the Robinson their permanent home celebrated their anniversary with "no serious arguments in 60 years of married life." The happy husband claimed, "The secret is, let the little lady have her way at all times." (Colourpicture Publication Company.)

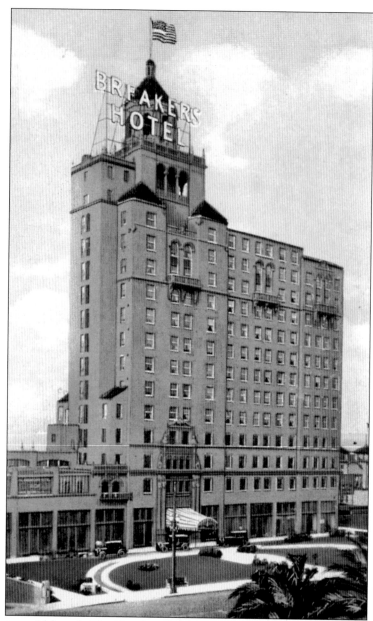

THE BREAKERS. Although The Breakers Club was described by a *Los Angeles Times* staff correspondent at its 1926 opening as an "imposing structure of ultra-Spanish architecture," the tower topping 15 stories gave it "a prominence greater than any other in the city." Even if Walker and Eisen had not been preeminent architects of the Deco period, it would still be impossible to ignore. Lavish decoration with mermaids, Spanish galleons, and Neptune surround the door and decorate the lobby. When it opened, it featured parking for 50 cars, hot and cold seawater for each bath, radio connections in every room with a broadcasting station in the tower, and dancing in the roof garden. Sold to Conrad Hilton in 1938, it was renamed the Wilton when it changed hands again in 1947. The building at 200–220 Ocean Boulevard is now a senior residence. A postcard writer states, "God's Fairyland, beautiful beyond description." Was the writer referring to the Breakers or the city itself? (Western Publishing and Novelty Company.)

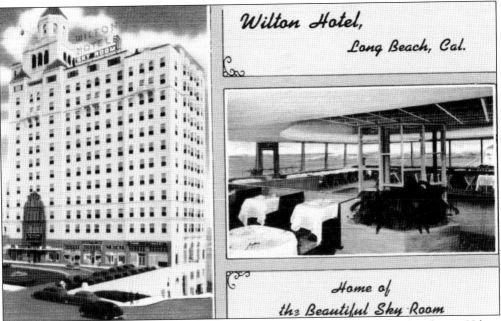

THE SKY ROOM. The Sky Room and Terrace was probably the most spectacular change Hilton made. Covering the entire top floor and surrounded by walls of glass, dancers could "look down upon the ships of the battle fleet and other craft in the harbor." It was advertised with Deco drawings of patrons riding up cloud elevators to sip aperitifs and dance on clouds. (Colourpicture Publication Company.)

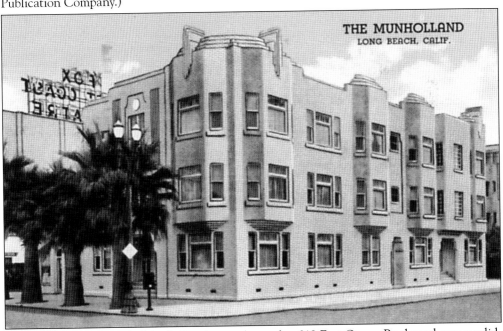

THE MUNHOLLAND. The Munholland, once located at 319 East Ocean Boulevard, was a solid-looking building topped with fanciful fins. Entertainment was plentiful for those who rented the apartments: it was near the beach, backed up to the Fox West Coast Theatre, and in 1930 it was across the street from a miniature golf course. (Inman Company.)

ATLANTIC STUDIO. A small, multifamily dwelling with ground-floor storefronts at 226 Atlantic Avenue, although subject to much remodeling, retains elements of its past. Constructed in 1933 by Wayne Foster for Leo Jamposky, the concrete facade with brick walls on the sides suggests that it may have been one of many buildings that were partially rebuilt after the original front crumbled in the quake. The architect was J. R. Friend.

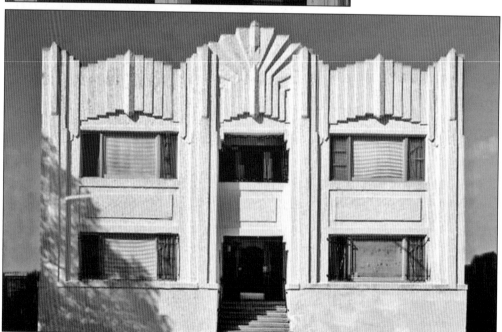

327 WEST SIXTH STREET. The designer of this delightful 1930 building remains anonymous. His creation, however, was called the Marvin Apartments. The parapet, with its central-fluted sunburst, is reminiscent of the Russian-style wedding crowns that were all the rage for brides in the mid-1920s.

527 EAST THIRD STREET. Another late-Deco building, these apartments were constructed in 1947 for Mr. and Mrs. G. T. Davis. The awning above beautifully echoes the inward curve of fluted turquoise tile that leads to the door.

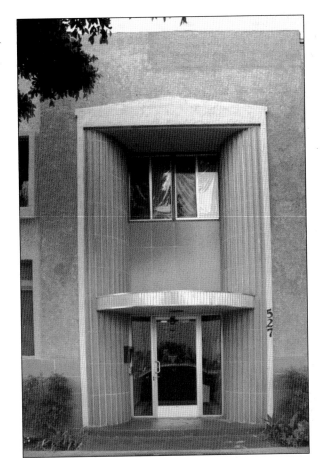

1901 EAST THIRD STREET. During the early 1940s, there was a brief period when architects were named on Long Beach building permits. George Kahrs, a prominent long Beach architect, designed this Streamline Moderne apartment building in 1941 for owner Robert Lee Graham.

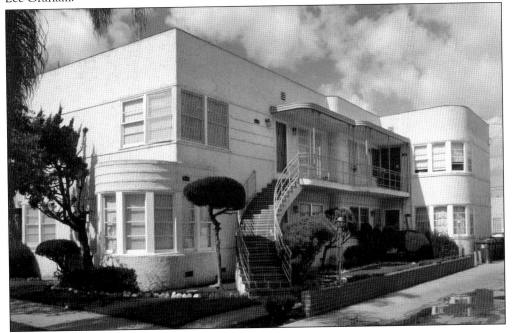

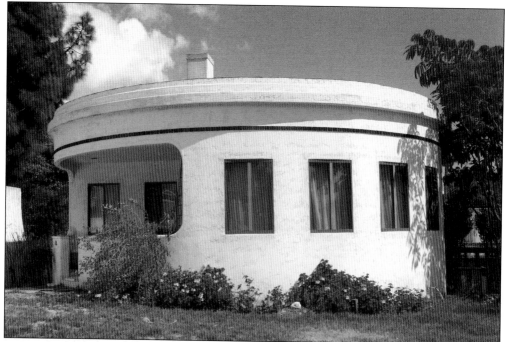

206 Quincy Avenue. It is rare to find a building with a truly oval footprint, but this Streamline Moderne house comes close. Built in 1937, the simplified form and speedlines around the top seem influenced by a nautical style except that the windows are rectangular rather than round like portholes.

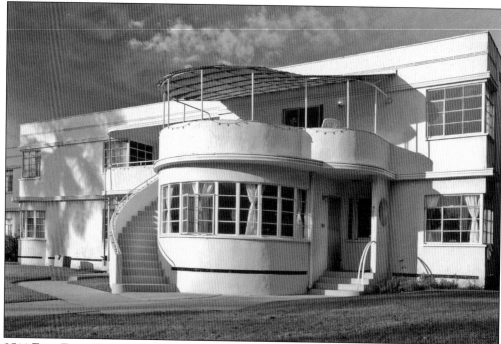

3511 East First Street. In 1922, owner Frank Mizzi built flats here. This ship-shape, Streamline Moderne building, complete with portholes by the door, is most likely a post-quake replacement.

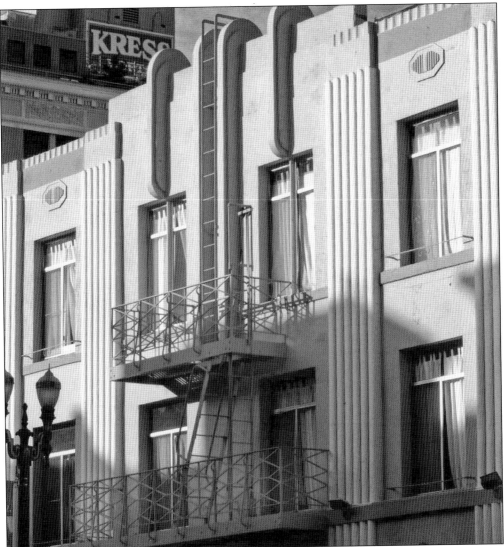

519–521 PINE AVENUE. Traces can be found of the people who chose to make this lovely building, constructed in 1924 and altered in the 1930s, their home. An employer advertising for an experienced millinery saleswoman in 1937, a girl jailed for speeding in 1928, a man rescued by firefighters in 1935 when a blaze caused extensive damage, wedding announcements galore, a death or two, and an occasional arrest—all these people lived or worked behind the frozen waterfall adorning the facade of the Felt Apartments. Waterfalls and frozen fountains had been an important motif since *L'Exposition* and were found in the work of René Lalique and other artists of the time. They were frequently employed as a decorative element in the 1930s, wrapped around rooflines and cascading down the walls of a building. This one most likely dates to the post-quake remodeling.

413 East Seventh Street. The geometric bas-relief over the door and upper window of this building give it a cheerful aspect, especially since the current owner has picked out the design in bright, warm colors. Work on brick and board and plaster was begun in April 1933 for owners Herman and Emily Stankey, most likely to repair earthquake damage.

601 Linden Avenue. This 12-family building, the Linden Apartments, was constructed for A. J. Dickard of Pasadena in 1929. Apparently there was an earlier building, however, as a 1920 article describes two residents who were badly hurt when their light touring car "turned turtle." In 1934, extensive repairs were made to the building, which was then owned by Allied Properties, who operated a large number of hotels and apartments throughout California.

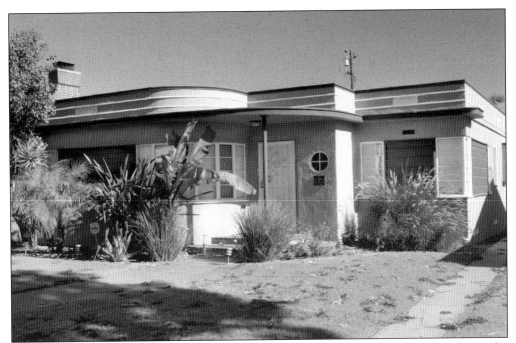

CHENEY-DELANEY HOUSE. A relatively rare example of single-family Streamline Moderne, the two-bedroom house at 2642 Chestnut Avenue has an interior displaying the hallmarks of the style. The entry hall features a curved wall and stepped pyramid arch; the den is paneled in blond wood with unusual panels over the windows repeating the stepped pyramid pattern with recessed lighting. The kitchen also makes use of curved corners.

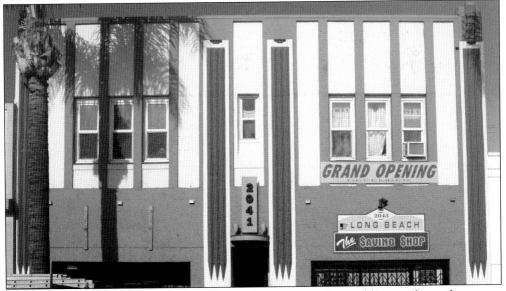

2039–2041 NORTH PACIFIC AVENUE. It wasn't unusual to find buildings with retail space on the ground floor, which in this case was L. M. Slage's grocery store, with apartments above. This mixed-use building was constructed in 1929 for Elizabeth C. McDonald and altered in 1933 by T. P. Hunter, presumably to repair earthquake damage. A third owner replaced the original windows with aluminum and plate glass in 1969.

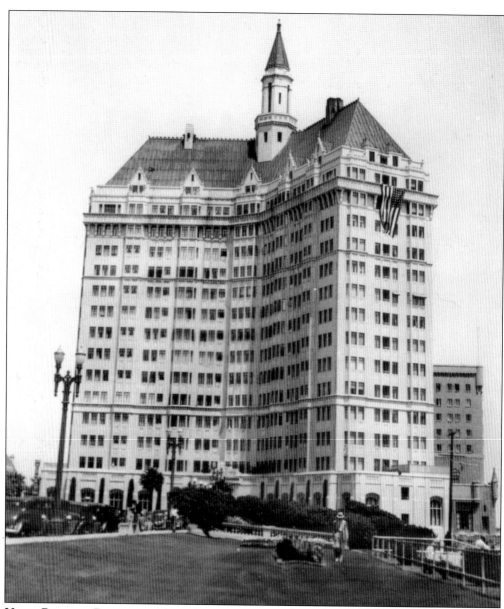

VILLA RIVIERA. Dominating the Long Beach skyline since 1929, the Villa Riviera at 800 East Ocean Boulevard was the second-tallest building in Southern California, exceeded in height only by Los Angeles City Hall. Richard D. King won the contract to design the 16-story "Tudor Gothic"–style building in an international design competition. Rising to a height of 280 feet, it also descended to a depth of 300 feet with subterranean parking that would accommodate 300 cars. Built as an "own your own apartment" cooperative, the building became a residential hotel after the Depression. Briefly owned by Joseph M. Schenk of Twentieth Century Fox, who purchased it for his ex-wife, actress Norma Talmadge, the building has come full circle and is now condominiums. Always luxurious, apartments originally came furnished with "carpets of rich quality," dinnerware, silverware, "full length cheval mirrors in the bedrooms," maid's rooms, and a roof garden according to an original 1928 brochure. Although dwarfed by later development, its height and beauty keep it a vital feature of Long Beach, silhouetted against the sky. (Photo uncredited.)

Three

ENTERTAINMENT
JUST FOR FUN

People came to Long Beach for many reasons—to live, work, or just to play. Tourists came for the sunshine and the ocean; both visitors and residents found entertainment near the shore. From the turn of the century, the California coast was dotted with amusement piers and the Long Beach Pike was one of the biggest and best. There were always dances, music, and parties. A 1924 contest led a radio station to choose the slogan, "Long Beach, California—where your ship comes in." Decades later, the city's ship did come in when Cunard's *Queen Mary* steamed into Long Beach harbor to spend her retirement as a hotel and tourist attraction. In 1928, the Pacific Southwest Exposition was nearly big enough to rival a World's Fair. And after all the frivolity, one could always go to church. Long Beach was known as an upright city full of churchgoers; only one church, however, was built in the Deco style. Some of the venues that attracted visitors in the early 20th century are still there, while others have fallen victim to changing tastes. The Pacific Southwest Exposition is forgotten, the radio stations have new formats, the Pike is just a memory, and the *Queen Mary* is struggling for continued existence. The beach and the sunshine, at least, still remain constant.

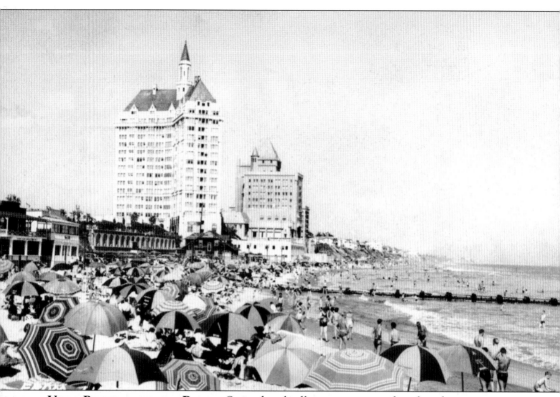

VILLA RIVIERA AND THE BEACH. Striped umbrellas may come and go, but skyscrapers towering over other beachfront residences were part of the view that tourists wrote home about. The writer of this card, dated December 26, 1942, states, "I'm out here on this beach right now . . . wish you were here enjoying this clean warm sand." Over the years, tourists have contributed mightily to the economy of Long Beach. Arriving by train or by road, they could find a cozy hotel near the sea and spend their vacation days splashing, sunning, strolling, or taking advantage of the many opportunities for shopping and entertainment the city offered. The postcard writer also mentions a dinner of "french fried shrimp fresh out of this ocean." (Postcard uncredited.)

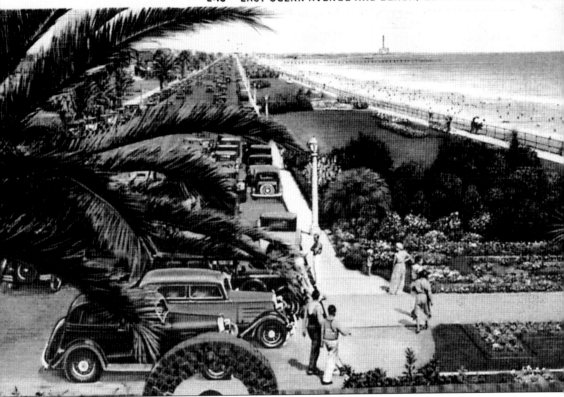

East Ocean Avenue and Beach. Southern California's biggest draw for tourists was, of course, the beach. Postcards conveyed an idyllic landscape of sunshine, palm trees, flowers, and waves rolling gently to shore, specifically designed to make people from less temperate climates envious. By 1938, when this card was mailed, pants on women had become less shocking. A few years earlier, however, wide-legged beach pajamas, like those on the woman in this image, were condemned by mothers and women's clubs. They were grounds for divorce in 1931 when a husband tore them off his soon-to-be ex-wife, but were in compliance with a law requiring covering "down to the knee for all bathers or beach baskers not actively engaged in beach pursuits." A 1928 beauty contest featured young ladies in beach pajamas parading behind a screen, the sun behind them silhouetting their figures for the judges' pleasure. (Western Publishing and Novelty Company.)

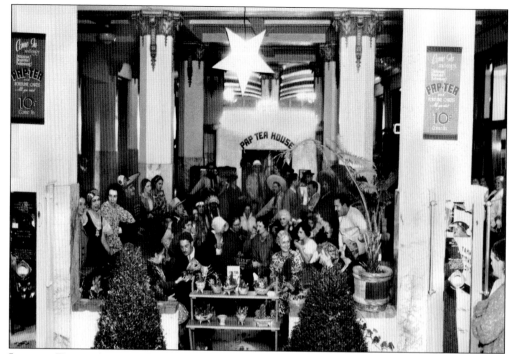

JERGINS TRUST ARCADE TUNNEL. In 1928, an elegant tunnel lined with Italian ceramic tile opened, allowing pedestrians to traverse the distance to the beach without having to cross the streetcar line. The 30-foot-wide tunnel leading from the Jergins Trust shopping arcade to the shore contained a small number of concession stands and shops. This teahouse is gone, but a woman eyeing the scale suspiciously is eternal. (Courtesy Historical Society of Long Beach.)

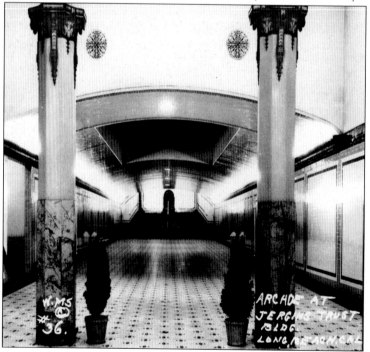

JERGINS TRUST ARCADE TUNNEL. A number of Long Beach businesses maintained showers and lockers to allow workers to spend their lunch breaks swimming or watching the waves. The tunnel is now closed to the public, but preservationists are hoping it will someday reopen. It is, however, highly doubtful that businesses in this century will ever encourage their employees to lunch at the beach. (Courtesy Historical Society of Long Beach.)

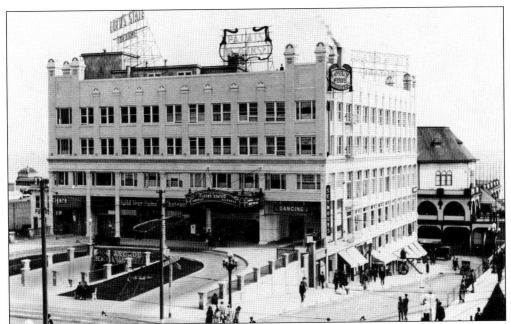

JERGINS TRUST. Despite a fierce battle by preservationists, the Harvey Lockridge-designed Jergins Trust Building at Ocean Boulevard and Pine Avenue was demolished in 1985 to make way for a luxury hotel that was never built. A. T. Jergins was a prominent figure in the development of the oil industry. His penthouse office had walnut paneling with a hidden door concealing secret storage space. (Courtesy Long Beach Public Library.)

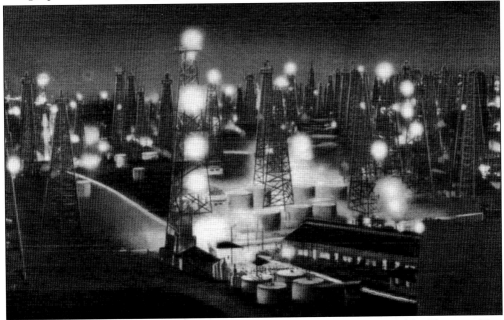

OIL FIELDS AT NIGHT. Although this 1937 postcard makes the wells look more like Christmas Tree Lane, oil was big business in Long Beach. City-owned oil properties leased to companies like A. T. Jergins, which had sunk 14 oil wells and intended to add more, yielded a 40-percent royalty that had added $2 million to the city coffers by August 1924. (Western Publishing and Novelty Company.)

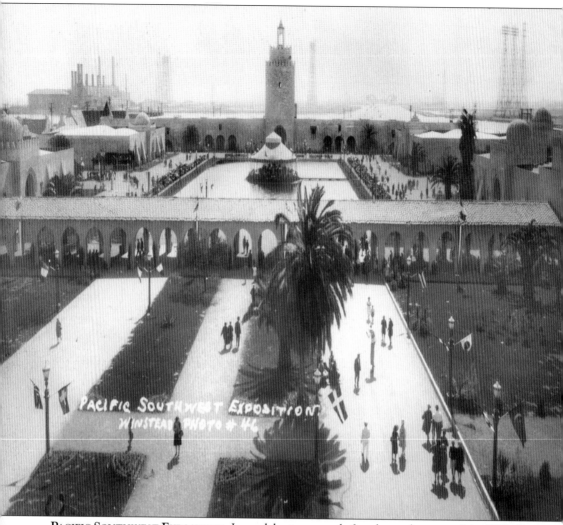

PACIFIC SOUTHWEST EXPOSITION. In a celebratory mood after the exuberance of the 1920s, Long Beach conceived the idea of an exhibition to rival the World's Fair: "forty days and forty nights crammed with world's fair features, displays of modern inventions and the best of all that the world has to offer," as Arthur G. Pangborn wrote. Architect Hugh R. Davies designed a Moorish-style wall surrounding 65 acres of buildings representing the cultures of the Pacific basin. The walls themselves housed buildings full of exhibits. Actors and dancers were hired to mingle with the crowd, costumed as snake charmers, market beggars, fakirs, and magicians. Lindbergh promised to attend, as did Dr. Hugo Von Eckener, who planned to fly his zeppelin to the fair. The zeppelin didn't make it, but presidential nominee Herbert Hoover did. Crowds who came for the noon opening stayed through dusk, when a million multicolored lights were turned on for the first time by actress Gloria Swanson, illuminating the night and announcing the presence of the Exposition for miles around. (Postcard uncredited.)

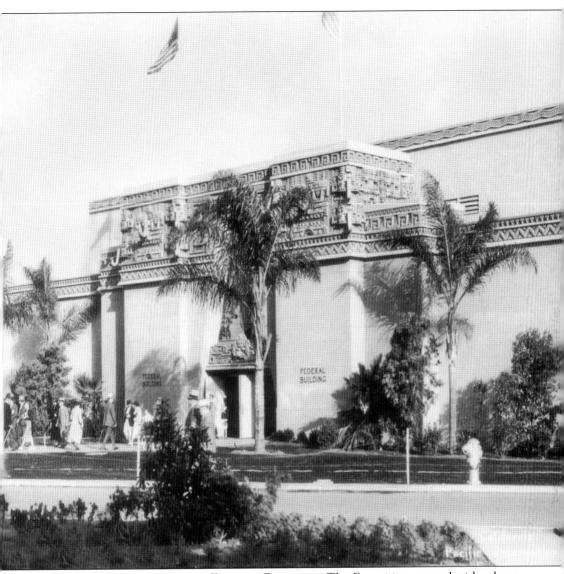

PACIFIC SOUTHWEST EXPOSITION FEDERAL BUILDING. The Exposition opened with a bang on May 27, 1928. Unfortunately, it also ended with a bang in September when the tower at the main entrance to the Palace of Fine Arts collapsed, injuring four people, which may be why the structures, including this Mayan-influenced building, were not donated to the city of Long Beach to be used as a permanent museum and art gallery as originally planned. Most visitors, however, suffered no more than sore feet from trying to see everything. There were exhibits devoted to the control of the prairie dog, a miniature German cathedral, methods for growing hair and methods to keep it from growing, motor cars, machinery, and Krishnamurti's message of happiness. There were races and water sports and opera singers and, of course, sandwiches, sodas, and various treats available to revive flagging energies. (Postcard uncredited.)

SEVENTH-DAY ADVENTIST CHURCH. Most churches are funded through donations, and most congregations prefer a time-tested style, so almost all churches built between the two world wars are in a Gothic, Spanish, or other traditional style. The Seventh-day Adventist church at 1001 East Third Street is an exception. The 1941 building includes the setbacks, vertical lines, and stair-step styling that we have come to associate with Art Deco.

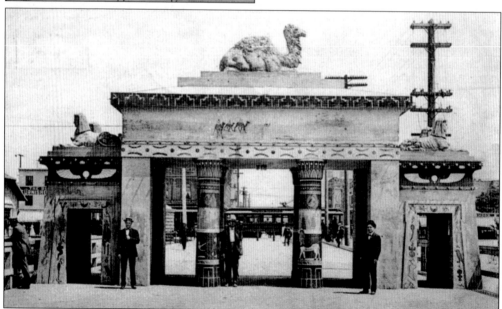

SHRINERS ARCH. Although it predates the Deco era, the 1906 Shriners' Arch foreshadows the Egyptomania that took the world by storm in 1922 when Tutankhamen's tomb was discovered. The Egyptians built for eternity; the Shriners' arch, built of plaster, was not intended to last. The huge camel, lit by 1,000 incandescent bulbs in its heyday, survives only in photographs. (R. H. Stocoum.)

KFOX. During the earthquake, the front of radio station KFOX was "practically sheared off, leaving the members of the staff looking into the open street," but the broadcast continued. The *Los Angeles Times* reported, "They stood in the midst of falling debris and frightened folk and calmly appealed to the outside world for assistance." The station, which shared its space with a tire store, was rebuilt in a functional Deco style. (Green's, Incorporated.)

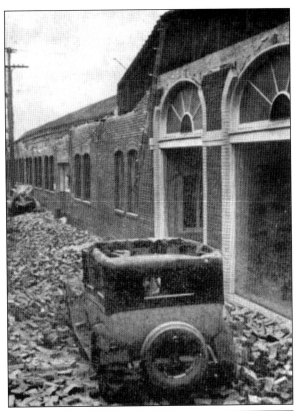

KFOX. On March 5, 1924, KFOX began broadcasting from the Markwell Building (later Jergins Trust). In 1928, the offices and transmitter were moved to 220 East Anaheim Street, the same year call letters changed from KFON to KFOX to celebrate a brief partnership with the William Fox Film Corporation. The call letters stayed even though William Fox declared bankruptcy due to the expense of converting theatres to sound.

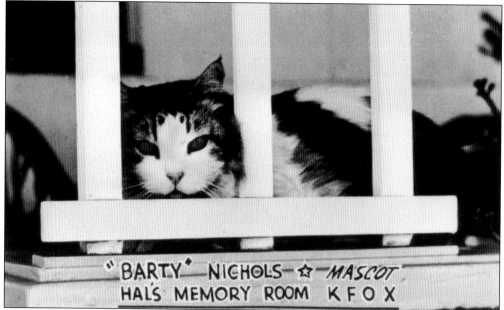

"BARTY" NICHOLS ☆ MASCOT
HALS MEMORY ROOM K F O X

KFOX CAT. Station owner Hal Nichols was one of the pioneers of radio in Long Beach. In 1935, he experimented with devoting all airtime to live programming. Before hitting fame in the 1940s, Poly High student Spike Jones and his band played jazz every morning before school. Around 1940, Nichols hosted an oldies show, occasionally sharing the mike with his cat, Barty, who would purr for the listeners. (Postcard uncredited.)

ROSE PARADE FLOAT. The Rose Parade in Pasadena has always been a uniquely Southern California way to express civic pride. In 1921, Long Beach took fifth prize with a glamorous queen of the sea, her princesses looking like silent-film stars among the roses. Later that year, it was decided that Long Beach would not enter a float for New Year's Day 1922, because it was too expensive. (Postcard uncredited.)

SAILOR AND GIRLS. Although Long Beach was always a popular tourist destination, owners of theatres, dance halls, and attractions on the Pike knew that the sailors coming ashore would perpetually be looking for entertainment. Photographs abound of sailors "in jail" with pretty girls. Long Beach commerce took a hit when the navy pulled out. The Pike, among others, never recovered. (Postcard uncredited.)

U.S. BATTLESHIPS AT ANCHOR. Until recently, Long Beach was a navy town. Many vintage postcard booklets represent the city with an image of U.S. battleships anchored just off the coast. Social columns were full of parties, dances, and weddings attended by officers and their wives. This photograph depicts two Long Beach icons: the U.S. fleet and the Rainbow Pier. (Fairchild Air Surveys, Western Publishing and Novelty Company.)

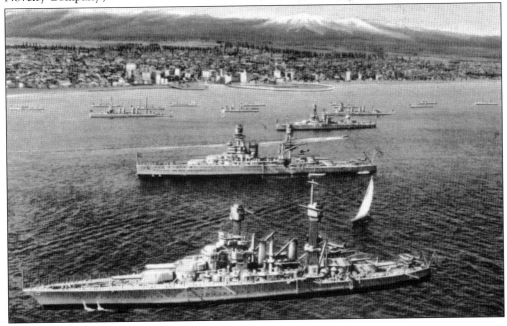

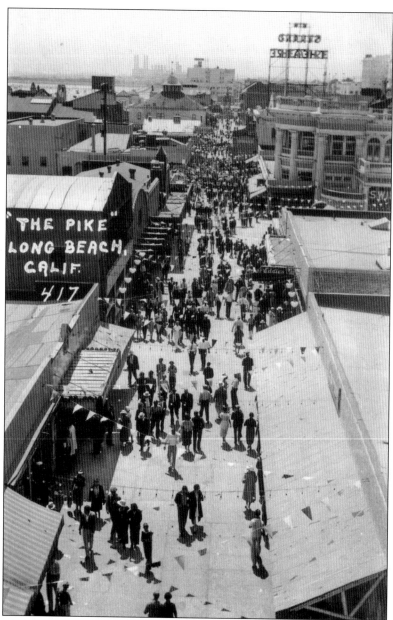

THE PIKE. Amusement parks lend themselves to good stories, and in its heyday the Pike had some of the best. A few are bizarre, like the Old West outlaw's mummy discovered hanging in a fun house during the filming of a television show, masquerading as a dummy until his arm fell off. Others are potentially horrifying but have happy endings. In 1923, two pythons escaped and wandered down to the beach. The smaller, 12-foot snake was recaptured immediately. A 10-year-old boy clambering over the rocks found the 35-footer about a week later. He sent companions for the police and maintained guard until help arrived to return the snake safely to its owner. Still others are sweet and funny. In 1938, two girls were overheard musing about why some British seamen had "H.M.C.S." emblazoned on their hats. One was overheard telling her companion, "Oh, I know, honey, it means His Majesty's Cute Sailors!" Now the stories are resurrected from moldering newspapers and the Pike is the name of a shopping center. (Photograph uncredited.)

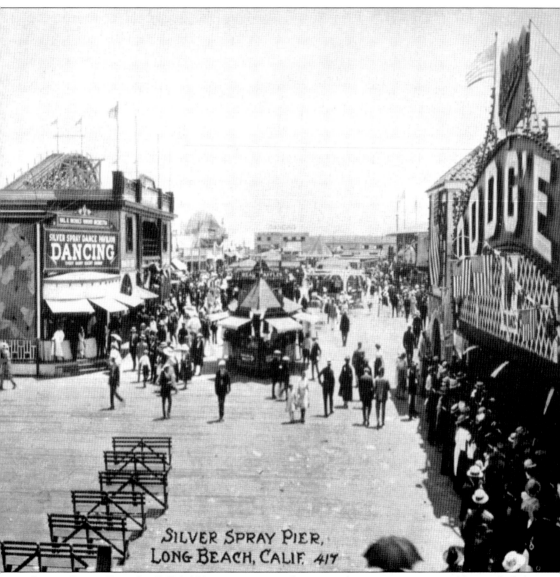

SILVER SPRAY PIER,
LONG BEACH, CALIF. 417

SILVER SPRAY PIER. In 1917, 2,000 contestants vied to name the amusement center that included the Long Beach Pleasure Pier and Neptune Pier. "Silver Spray Pier" won the $25 prize because, as one judge said, it "suggests the flaky ocean waves that rise along the shore, and because of its brevity and advertising possibilities." Propriety wasn't mentioned in the contest rules, but because "it is a woman's job to see that proper standards of conduct and costume are maintained," four policewomen patrolled the piers and the dance halls in 1924, charged with "keeping the amusement zone on a high moral plane." Morals figured prominently in *Los Angeles Times* articles about the amusement area. A year later, a parade that included beauties in bathing suits led some outraged citizens to propose a recall election "to oust the officials who are held responsible for permitting this pageant of pulchritude." The Silver Spray Pier was demolished in 1948. (Bardell Art.)

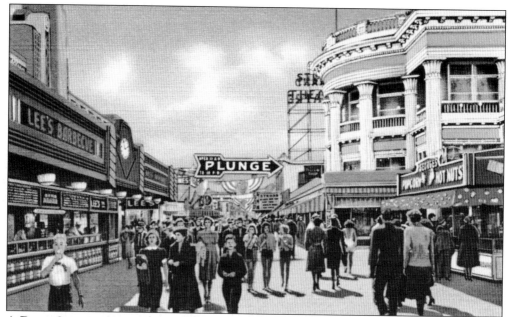

A Daily Scene on the Pike. The Pike, pictured *c.* 1940, showed signs of growth. The pillars belong to the Bathhouse, built in the early part of the century. Lee's Barbeque, on the other hand, is Moderne in speedlines and setbacks. (C. T. Art Colortone, Western Publishing and Novelty Company.)

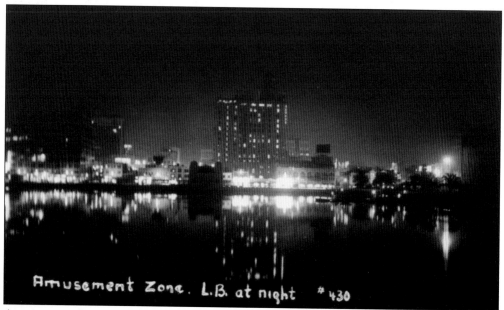

Amusement Zone at Night. At night, the amusement zone at the beach was lit up with reflections in the water doubling the brilliance. This *c.* 1938 photograph shows the Breakers after it had become a Hilton Hotel but before the Sky Room was added. (Photograph uncredited.)

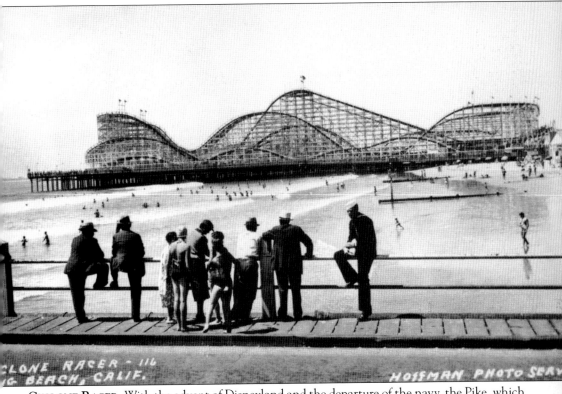

CYCLONE RACER. With the advent of Disneyland and the departure of the navy, the Pike, which had been renamed Nu-Pike in a desperate attempt to seem more current, fell on hard times. Long Beach did not have the foresight of Santa Cruz, where a similar amusement pier was cleaned up into a thriving tourist attraction. The decision was made that, as one headline lamented, "The Nu-Pike May Be No Pike." The Rainbow Pier was demolished in 1955 and a landfill was added that moved the shoreline about a quarter mile away from the Pike. The amusement pier grew increasingly more rundown and became scary for all the wrong reasons. The Cyclone Racer that terrified and delighted people from 1930 to 1968 gave way to the freeway, which may terrify but rarely delights. (Whelan.)

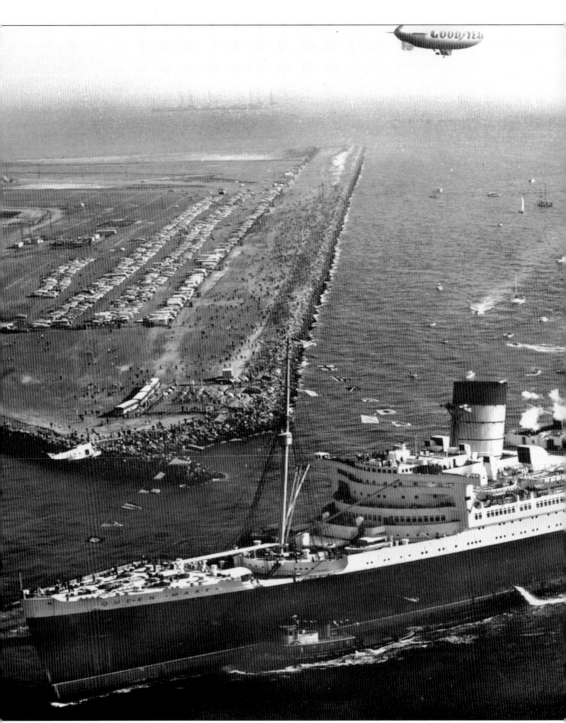

QUEEN MARY ENTERING LONG BEACH. Thousands cheered when Queen Mary broke a bottle of wine on the bow of the ship that shared her name—the first time a reigning queen of England had named a merchant ship. Of course, Cunard's *Queen Mary* was no ordinary ship. Her forward funnel is taller than Niagara Falls, and she is almost as long as the Empire State Building is tall. A London astrologer's odd prediction held some surprising truth, "Most of this generation will

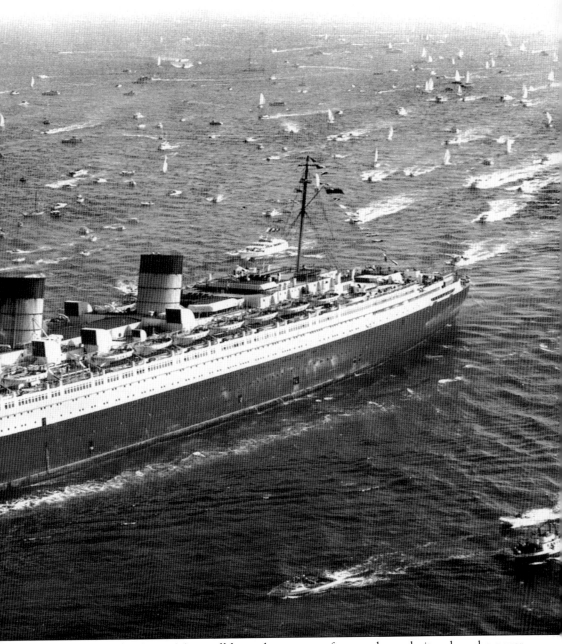

be gone . . . but the *Queen Mary* will know her greatest fame and popularity when she never sails another mile and never carries another paying passenger." On December 9, 1967, the most celebrated Deco transplant steamed into Long Beach accompanied by a flotilla of pleasure ships and watched over by the Goodyear blimp. (Courtesy Historical Society of Long Beach.)

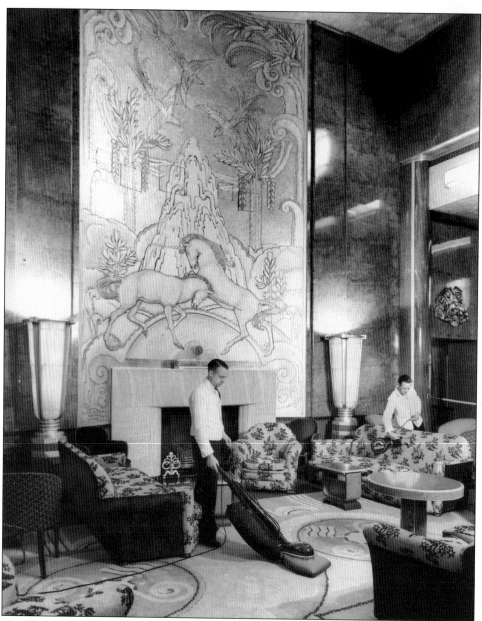

FIRST-CLASS MAIN LOUNGE. The stewards vacuuming the carpets are from around 1947, but the huge carved gesso panel, *Unicorns in Battle*, behind them was in place before the *Queen* first set sail. The silver-and-gold-tinted panel by Alfred J. Oakley and Gilbert Bayes has unobtrusive doors above the unicorns, and a movie projector behind them could turn the room into a cinema. The wood-paneled room, the second largest on the ship, has three levels of windows, several fireplaces, and enormous onyx-urn lamps that cast a soft glow over the evening. Peach-tinted mirrors flattered the complexion, which was a boost to the mood of a passenger who may have been feeling a bit green on a seasick voyage. Although many letters talk about the *Queen Mary's* notoriously rough crossings, the writer of one card was enchanted: "I thought you would like to know I am on the wonderful Queen Mary. . . . Oh, she is magnificent and there is a very big crowd on her . . . 1400 passengers to sail tomorrow." (Courtesy RMS Foundation.)

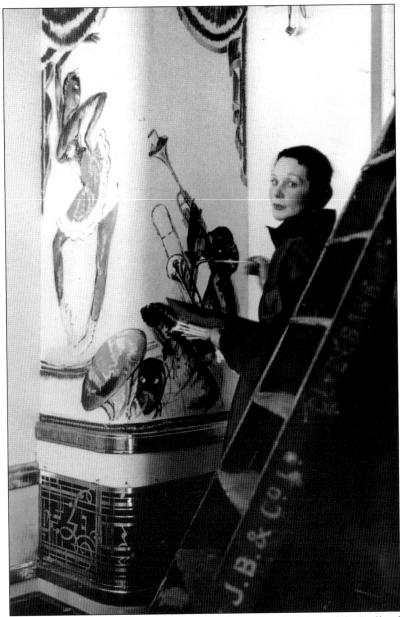

VERANDAH GRILL. Doris Zinkeisen created the décor for the Verandah Grill, which was a small, exclusive room with a bay of 22 windows overlooking the stern that served as a cocktail lounge and nightclub for first-class passengers. Every detail was thought out, as evidenced by the musically inspired grillwork at the artist's feet. A sunken parquet dance floor, surrounded by an etched glass balustrade, invited couples to waltz or foxtrot. Black carpet furnished a dramatic background for those who preferred cocktails and conversation. The central section of Zinkeisen's oil-on-canvas mural, *Entertainment*, was damaged during World War II when the *Queen Mary* was used as a troop ship. The artist later reconstructed it. Doris, who also designed costumes and sets for theatre and film, frequently worked in collaboration with her sister Anna on commissions for the *Queen Mary* and *Queen Elizabeth*. The room has been recently restored to its original glamour. (Courtesy RMS Foundation.)

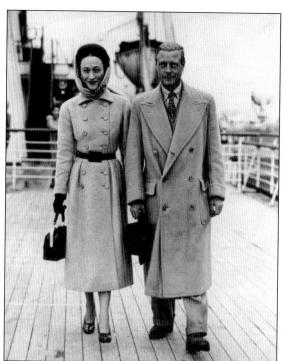

DUKE AND DUCHESS OF WINDSOR. Rumor has it that the Duchess of Windsor once objected to the décor in her room. As the ship was halfway across the ocean, the crew scrambled to divest other rooms of anything they could scrounge in her favorite green. It is verified that she and the Duke always booked the same suite, re-equipped in electric blue and green. (Courtesy RMS Foundation.)

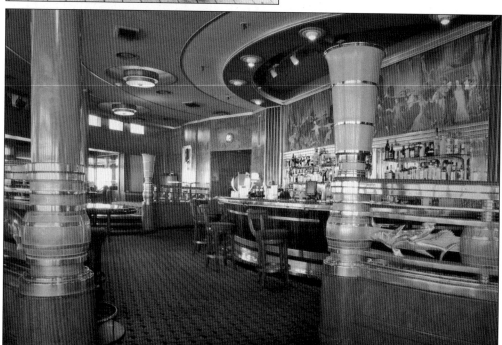

OBSERVATION BAR. The list of celebrities who didn't sail on the *Queen Mary* may be shorter than those who did. It was said there were enough shipboard romances to keep a gossip columnist busy full-time. A romantic pair could whisper under A. R. Thompson's mural, *The Royal Jubilee Week,* while a stepped platform, surrounded by Austin Crompton Robert's sculpted balustrade, compensated for the bow's rake.

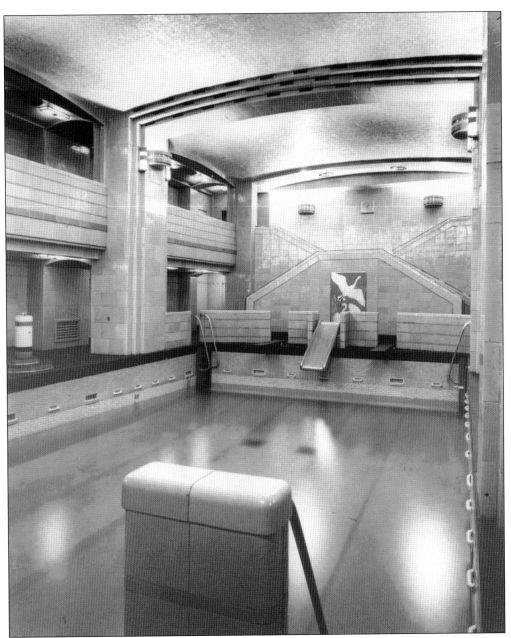

FIRST-CLASS SWIMMING POOL. At one time, a swimmer announced he intended to swim from New York to England. Only later did he add that he would be performing this feat in the *Queen Mary's* pool. The first-class pool used beige tile banded in green and a vaulted ceiling of simulated mother-of-pearl to brighten the area, which received no natural light. The staircase facing the pool included a panel of sandblasted glass with cranes in flight by C. Cameron Baillie and balconies visually heightened the limited space between decks. Passengers of an adventurous nature could enjoy the waves crashing from one side of the pool to the other in rough weather. There was a slide into the rather shallow pool for tamer days. Other exercise onboard ship could be had in the gymnasium, which, in addition to "electric horses," had a taller version called a camel-riding machine. (Courtesy RMS Foundation.)

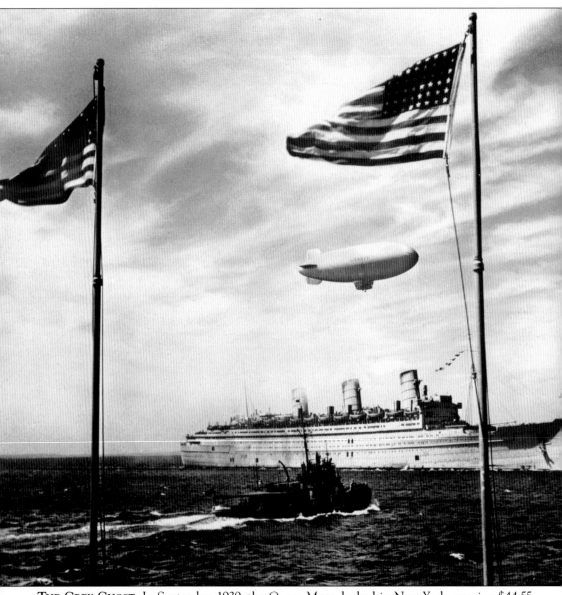

THE GREY GHOST. In September 1939, the *Queen Mary* docked in New York carrying $44.55 million in gold and 2,331 passengers fleeing the war in Europe. Her next appearance was cloaked in grey paint, using her speed and an ever-changing course to outwit German torpedoes as she ferried troops across the Atlantic. Winston Churchill made several crossings during those years. In May 1943, a diary written by Field Marshal Viscount Alanbrooke recounts Churchill's dismay at finding the ship " 'dry.' At this Winston pulled a very long face, but was reassured that the suite occupied by him need not be." The *Queen Mary* carried soldiers to and from the front throughout the war. She never fired a shot in anger nor was she ever fired upon, and when the war was over, she had the happier task of bringing European war brides and their babies to join husbands in the United States. (Courtesy RMS Foundation.)

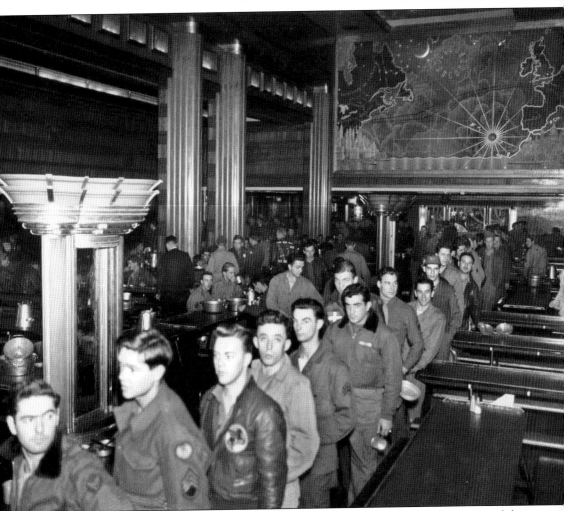

GRAND SALON DURING WARTIME. The interior of the *Queen Mary* was designed to surround the traveler in luxury. Even in 1940, when the first-class dining room became a first-class mess hall, the room retained its grandeur. High above the diners, McDonald Gill's oil-on-canvas *Decorative Map of the North Atlantic* was a serene reminder of peacetime. Crystal models of the *Queen Mary* and the *Queen Elizabeth* once indicated their positions on the transatlantic voyage, which was rather irrelevant with the zigs and zags of her wartime route. Although she was among the most beautiful troop ships imaginable, the soldiers no doubt had other things on their minds. They were packed into every available space; even the swimming pool was filled with bunks. Original furniture still has names written on the bottom of drawers. (Courtesy RMS Foundation.)

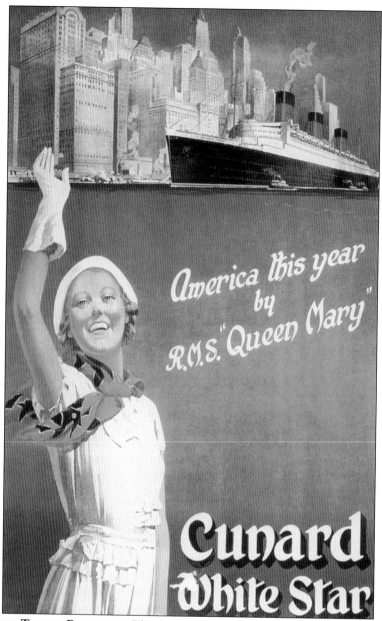

America this year by R.M.S. "Queen Mary"

Cunard White Star

QUEEN MARY TRAVEL POSTCARD. The *Queen Mary* was planned to be the centerpiece of a revived tourist trade in Long Beach. Her size fit in with the credo of "bigger is better" that has nearly destroyed the heritage of Long Beach. She might have fulfilled her promise had the city planners seen fit to surround her with a refurbished Art Deco city. Unfortunately, in the late 1970s and 1980s, the motto was "out with the old" and the city was taken apart piece by piece. Every few years, the *Queen Mary* is threatened with either sale or sinking. So far, she is surviving, but alert preservation efforts are always needed. Developers can make faster money by tearing down and building something cheap and shiny. History costs money to maintain and people looking for a fast buck rarely, if ever, have the time, foresight, or inclination to preserve it. The *Queen Mary* is the last of the magnificent Art Deco ocean liners. It would be a disgrace to lose her and be left with only optimistic postcards advertising her presence. (Courtesy RMS Foundation.)

Four

THEATRES
LIGHTS, CAMERA, DECO!

The movies brought Deco to the world. Architectural historian Robert Winter argues that "movies prompted a great many Americans to realize for the first time that architecture was, like other arts, a vehicle of expression." He quotes Dietrich Neumann: "Architecture had begun to act in movies; skyscrapers had risen to the status of movie stars." Certainly, the fledgling film industry was extensively influenced by *L'Exposition* and adapted the style enthusiastically. Not only did actresses in fabulous Deco clothes drape themselves over fabulous Deco furniture in fabulous Deco interiors, but every main street in every town had an elegantly appointed theatre. Going to the movies was an event, and the elaborate pylons and marquees of theatres emphatically announced their presence. In the age before the multiplex, the interiors were equally deluxe, with walls and ceilings as elaborate as any cathedral. The movies provided an escape from the Depression; in the theatre anyone could find luxury at a low cost. Unfortunately, many of the old theatres have been torn down. The remainder have mostly been remodeled and reused as commercial buildings, lofts, condos, or churches, sometimes with historic sensitivity but too often with no eye to the past.

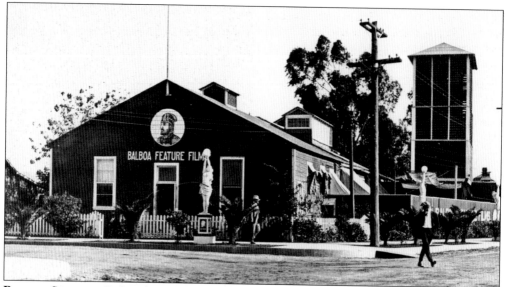

BALBOA STUDIOS. Before the industry moved north to Hollywood, sunny Long Beach was the capital of filmmaking. From 1918 to 1923, Balboa Studios boasted the talents of top silent-film stars and directors, with all the conflicts and scandals inherent when scantily clad actresses, drugs, and alcohol collided with a supposedly "dry," churchgoing community. One of their biggest stars, in many senses of the word, was Roscoe "Fatty" Arbuckle. (Courtesy Bison Archives.)

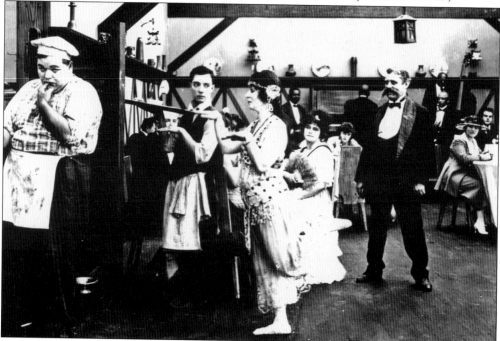

BALBOA STUDIOS STARS. In the 1918 film *The Cook*, Arbuckle (left) and Buster Keaton (second from left) wreak havoc at a seaside resort. In 1921, Arbuckle was accused of real havoc with the violent rape of starlet Virginia Rappe at a party. She died a few days later. Arbuckle stood trial for manslaughter, and although a jury acquitted him, public opinion condemned him. His career never recovered. The studio was torn down four years later. (Courtesy Long Beach Public Library.)

ART THEATRE. At 2025 East Fourth Street, the Art Theatre is the last remaining neighborhood theatre in the city still showing movies. Spanish-style in 1924, a post-quake remodeling by Schilling and Schilling changed it completely, adding architectural flourishes like stepped piers, vertical fluting, a fernlike central pylon, black tile, and a colorful terrazzo floor. A 1947 renovation by Hugh Gibbs added a glass-block wall and remodeled the marquee.

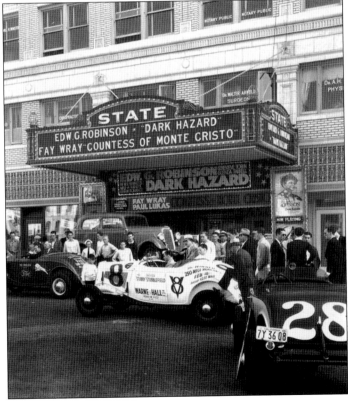

STATE THEATRE. In 1924, people flocked to see *Her Temporary Husband* at the State Theatre in the Jergins Trust Building. The *Los Angeles Times* reported that "almost every man, woman and child" had volunteered as extras during scenes shot in Long Beach. This 1934 photograph includes cars promoting "News Pictures Showing Stock Car Races Mines Field." Mines Field became Los Angeles International Airport. (Courtesy Long Beach Historical Society.)

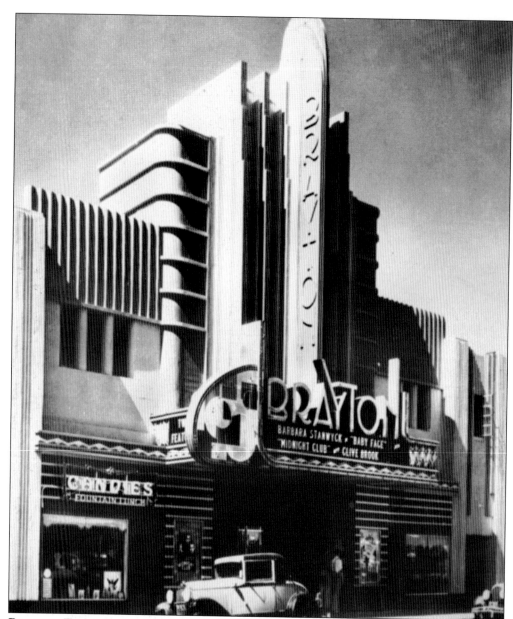

BRAYTON THEATRE. Theatre owner George F. Brayton was the twin of deputy district attorney William Brayton. In 1932, they shared the microphone at a twin convention that paraded from the Jergins Trust arcade to the lawn of the Hotel Virginia. The theatre Schilling and Schilling redesigned for George Brayton in 1933 wasn't an exact twin of anything, although it certainly had much in common with other theatres. A vertical pylon played against horizontal speedlines. More vertical lines curled to the roof, with horizontals at street level. It must not have been profitable, though, because when his wife sued for divorce in 1943, the theater owner and oil company executive claimed that he did not earn a single dime in the 10-plus years the couple was married. The Brayton Theatre was located, before its demise, at 2157 Atlantic Avenue. (Courtesy Long Beach Historical Society.)

ATLANTIC THEATRE. With neon flashing on its stair-stepped pylon, this neighborhood theatre must have lit up the night. An early 1940s design by architect Carl Boller, the theatre at 5870 North Atlantic Avenue featured a soundproof "cry room" so mothers with small children could enjoy the show. The pylon now calls people to church rather than the hotbed of iniquity many religious people expected from the movie industry.

IMPERIAL THEATRE. Clifford A. Balch and L. A. Smith designed the Imperial Theatre, which was next door to the larger Fox West Coast Theatre. Both were prominent names, as Smith designed many theatres and Balch was one of the primary architects for the United Artists chain. A polished terrazzo floor, made of marble or other stone chips set in mortar, enticed patrons through the door. It, too, is gone. (Courtesy Louise Ivers.)

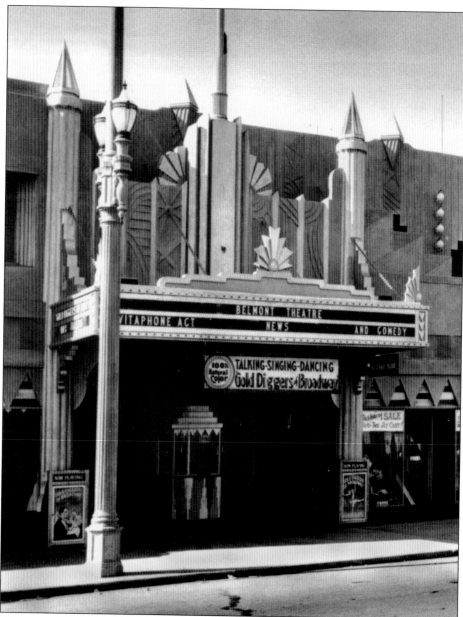

Fox Belmont Theatre Marquee. Spectacular in 1929, the Fox Belmont Theatre could only be described as Deco Exotic. The marquee featured elaborate sunbursts between minaret-like towers; the interior had murals of jungle animals. Doors were bold and geometric. Architect Reginald F. Inwood, who also designed churches, pulled out all the stops on this theatre. The auditorium was relatively simple, with lamps that mimicked speedlines. Banks of horizontal lines surrounded the stage, and the walls were covered with vertical stripes. Patrons accustomed to modern padded seating would not consider the lightly cushioned seats kind to their backs and posteriors, however, the elaborate designs supporting the armrests were much classier than any modern theatre can claim. The poster advertises *Gold Diggers of Broadway*, the 1929 precursor to the more famous Gold Diggers movies from the 1930s that featured Busby Berkeley dance routines. (Courtesy Stan Poe.)

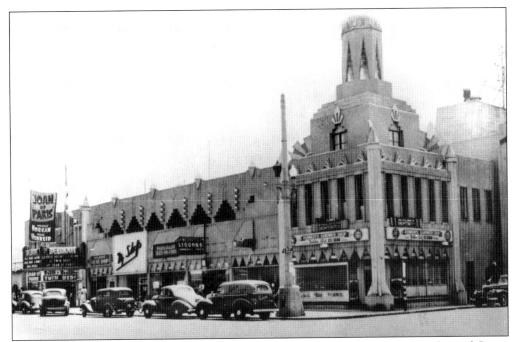

FOX BELMONT THEATRE. In a sign of the times, the Fox Belmont at 4918 East Second Street became a gym in the late 1970s, with a racquetball court and Jacuzzis replacing theatre seating and the hard work required of beautiful bodies today supplanting the illusion of effortless glamour of the silver screen. Elements of the original design remain on outside walls. (Courtesy Long Beach Public Library.)

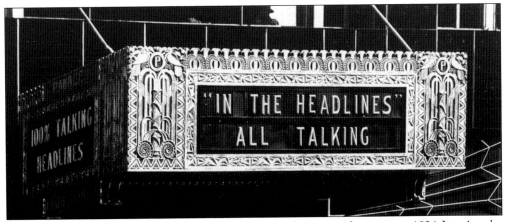

PALACE THEATRE MARQUEE DETAIL. The Palace Theatre took part in a 1924 *Los Angeles Times* contest in which reader's jokes were shown as part of a weekly "Local Laughs" film. In addition to the thrill of seeing one's name up on the screen, prizes of $1 to $5 were enough of a draw to keep people polishing those 30-words-or-less jokes. (Courtesy Historical Society of Long Beach.)

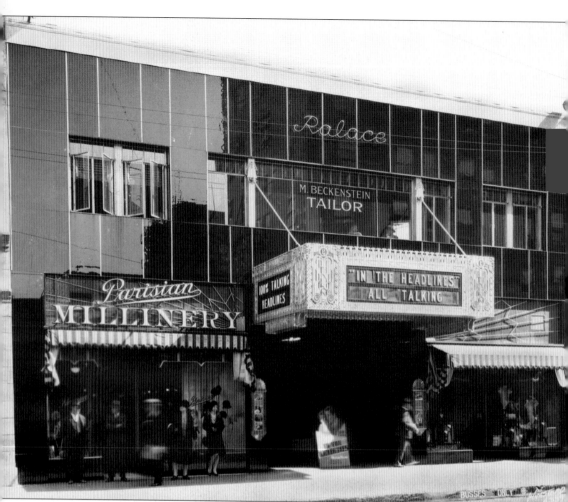

PALACE THEATRE. The Palace Theatre opened in September 1916, designed by H. Alfred Anderson. The exterior was altered several times; this photograph shows the 1929 marquee and facade by Merrill and Wilson. The front was altered again in 1938 and 1942. Perhaps they were trying to remain as fashionable as the hats next door at Parisian Millinery? The theatre did manage to attract a feminine safecracker in 1923. Apparently she took "silken fineries" as well as cash and left distinctive clues at the scene of her crimes. In addition to doing a very professional job of drilling out the combination lock of the theatre's safe, she was suspected of being involved in four other burglaries the same night. It would seem the lady got around. The theatre at 30 Pine Avenue is, like so many, now gone. (Courtesy Long Beach Public Library.)

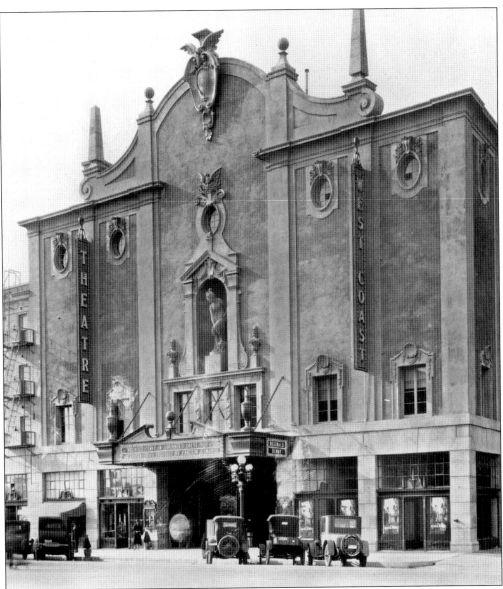

FOX WEST COAST THEATRE. Although the style was Spanish Revival, the Fox West Coast Theatre, located before its demise at 333 East Ocean Boulevard, was an important part of Deco-era Long Beach. A 1923 design by Meyer and Holler, the theatre survived the quake intact. An eyewitness quoted in the *Los Angeles Times* said, "People started swarming out of the West Coast Theater there. The first of them were just in time to get caught under an avalanche of bricks and mortar falling from a building beside the theater . . . I found my wife and we just sat down for a minute. . . . There didn't seem to be enough police officers to go around, but the Legion men and civilians who took charge handled the situation admirably." In 1925, the theatre took part in a search for an unknown actress to star in *The Winning of Barbara Worth*. Winner Marceline Day was "plucked from obscurity," but the 1926 film starred the more famous Vilma Banky. (Courtesy Long Beach Public Library.)

FOX WEST COAST THEATRE. The band in front of the box office was celebrating the silver jubilee for William Fox, owner of Fox Movie Studios. In 1904, Fox invested in a Brooklyn penny arcade. A year later, he put in a "picture show" upstairs. He bought theatres, and, in 1915, the Fox Film Corporation was formed. Vamp Theda Bara helped them make millions. (Courtesy Long Beach Public Library.)

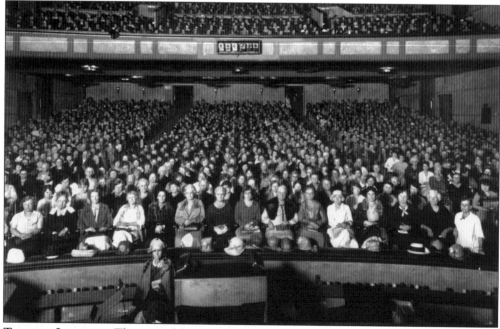

THEATRE INTERIOR. Theatres of the period were large and elaborate, designed to make movie-going an experience. Sitting in the dark, one could be whisked away to a world where one's day-to-day troubles ceased to exist. This 1927 photograph is believed to be the Fox West Coast Theatre. (Courtesy Long Beach Public Library.)

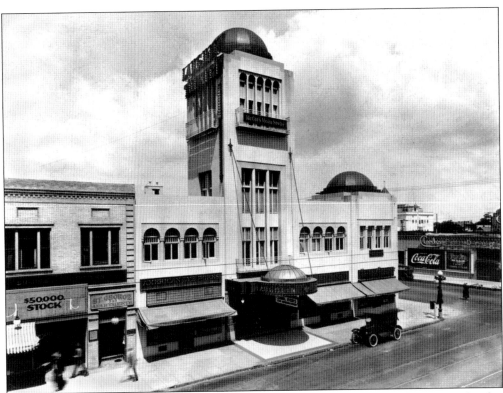

HOMER LAUGHLIN THEATRE. When Hanson Puthuff painted murals of the Sierras for this theatre, he made them four inches larger than the space so they could be trimmed to fit. The owner instead had his masons chisel concrete for a week so no part of the painting would be lost. Surprisingly the theatre, which predates the Deco era, was designed by acclaimed Modernist Irving Gill in 1915. (Courtesy Historical Society of Long Beach.)

HOMER LAUGHLIN THEATRE BOX OFFICE. This quintessential boy of 1927 seems to be contemplating the passage of time. Even in the Deco era, buildings did not last forever. Photographs show that the tower of the theatre at 347 Pine Avenue fell in the quake, although Gill's 1936 obituary claimed it came through unscathed. (Courtesy Long Beach Public Library.)

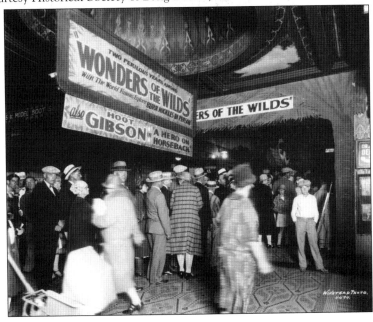

FANCHON AND MARCO. Fanchon and Marco were a brother-and-sister dance act that became phenomenally successful in the 1930s by putting on short musical stage shows before movies, with as many as 48 troupes of 24 dancers on the road at a time and still more applying for jobs every day. One dancer remembered being in Long Beach at the State Theatre when the earthquake hit. In 1919, Fanchon and Marco were interviewed about Prohibition and predicted that dancing would replace alcohol, "The shimmy is but a foretaste . . . the sensuous tango will be revived . . . four bars of it are as good as a cocktail." Dancing was certainly good to them, and it would appear from the sign in the photograph that they also lent their name to merchandise. In the background at left is the Robinson Hotel, with the Cliff Dwellers Inn at right. In 1920, a flurry of stories appeared around an amnesia victim living there; the man was eventually reunited with his family. (Courtesy Long Beach Public Library.)

CREST THEATRE. "Not the picture, but the theater," as the *Los Angeles Times* stated, had its world premiere in 1947. The Crest was a prefabricated theatre, the first of its kind according to Charles P. Skouras, president of Fox West Coast Theater Corporation. Although late for Deco, the theatre at Atlantic Avenue and Burlingame Drive hewed to the look made popular in the 1920s and 1930s with a tall, neon-lit pylon. Its opening was attended by stars and spotlights with crowds of onlookers sharing the excitement. Skouras said the theatre, "which seats 1,164 persons, will be made in Southern California and shipped to wherever films are shown." He added that smaller theatres, seating as few as 400 people, would also be a possibility "as soon as materials are available." (Courtesy Historical Society of Long Beach.)

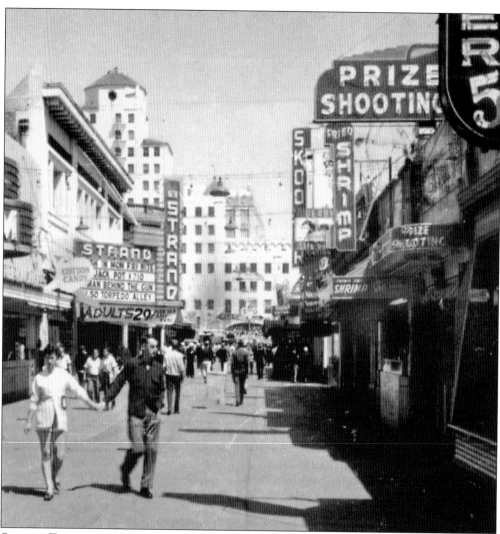

Strand Theatre. This 1953 photograph doesn't hint at the Strand Theatre's venerable history. Located on the Pike, it started life as a vaudeville house called Hoyt's. In 1930, it was renamed the Strand and blended vaudeville and films because, the manager said, "People are getting tired of all talking-picture programs and are demanding stage entertainment." The *Los Angeles Times* followed Fatty Arbuckle fight to be allowed to perform there after his acquittal. His apologies swayed some but not all. A councilman sarcastically offered to contribute to a fund to get "this poor boy out of debt" but not to permit him to appear onstage. Refusing his offer of money, Arbuckle pointed to a flag and said, "I am asking merely for what that flag guarantees me—truth, liberty, and justice." A spectator "cited the case of Jesus and Mary Magdalen." The councilman "came back with the declaration that Jesus did not permit Magdalen, following the forgiving of her sins, to enter a theater and there claim her contact with Jesus." The council voted in Arbuckle's favor, trusting "he had reformed and was trying to make good. (H. S. Crocker Company.)

Five

PUBLIC BUILDINGS
THE INFLUENCE OF
FEDERAL WORK PROJECTS

Even during the Depression, people were confused about the alphabet soup that designated the various federal projects. A 1936 article explained, "PWA is the Public Works Administration. WPA is the Works Progress Administration. Each is a Federal organization financed out of the same fund and intended to provide work for the unemployed." The differences had to do with how the work was financed. Under the PWA, a government unit could get money to build a public work with labor done by a contractor at regular wages. The WPA would not only provide workers but would pay them as well. The operation of the WPA was much more extensive, and it frequently received credit for PWA projects. So many public buildings were financed through the agencies that WPA Moderne came to signify a solid building with straight lines, setbacks, and usually some form of decorative detail near the windows, doors, and/or roofline. Public art projects were financed through the WPA Federal Art Project or the Fine Arts Project. Although a number of schools and murals survive, the post office is one of the few intact representatives of a Depression-era government building in Long Beach. The others were demolished in favor of 1970s and 1980s corporate styling.

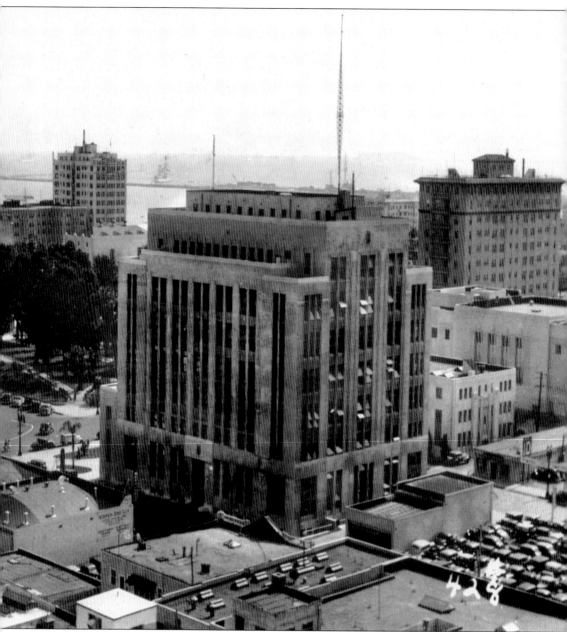

CITY HALL. One would think that opening a new city hall would be more spectacular, but Long Beach got far more press in 1922–1923 when, in response to the WCTU (Women's Christian Temperance Union), they prohibited smoking in the new eight-story building. W. Horace Austin's blueprints replaced an earlier building designated as a "firetrap." His design fell to redevelopment in the 1970s, although it lasted longer than the ban on tobacco did. In other scandals, a councilman in 1924 took office workers to task, claiming they were shirking their duties and taking Saturday afternoons off. Political grandstanding never changes. Or maybe it does, as the same councilman introduced a bill that would require owners of chickens to reconstruct their coops in such a manner that when the rooster stood up, flapped his wings, and prepared to crow, he would hit his head against the roof that would, no doubt, silence him. (Postcard uncredited.)

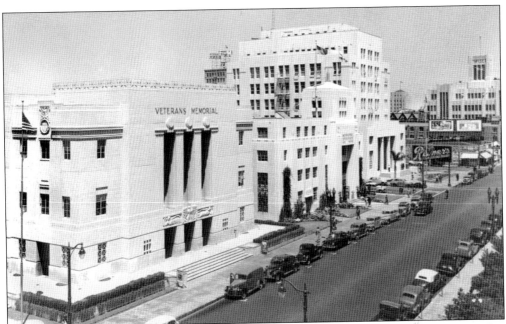

VETERAN'S MEMORIAL. The dedication of the Veteran's Memorial, designed by George Kahrs at Broadway and Cedar Avenue, followed the Armistice Day parade in 1937. Sculptor Merrell Gage created horizontal reliefs depicting states of peace flanking a panel of an American eagle for the facade of the building. They were lost with the building. The Public Utilities Building, which was also demolished, is in the background. (Tichenor Art.)

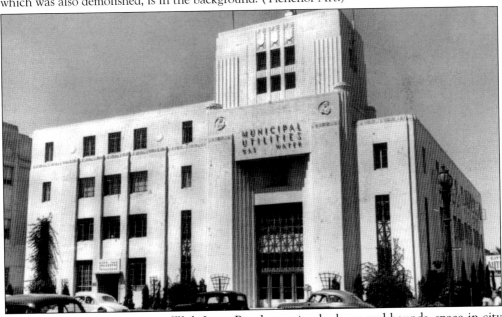

PUBLIC UTILITIES BUILDING. With Long Beach growing by leaps and bounds, space in city hall was at a premium. In 1931, it was determined that a building to house gas, water, and other municipal departments was needed. In 1939, enlargements were halted when two ornamental iron workers were not required to join the union. Two men walked the picket line, and the other 40 did not appear for work. (Postcard uncredited.)

LONG BEACH POST OFFICE. It was said in 1935 that Long Beach had grown so fast that "the government jumped from rental to rental trying to keep up." The post office, opened in 1934 at 300 North Long Beach Boulevard, must have helped. The terra-cotta sheathed WPA Moderne building, designed by James E. Wetmore and Louis A. Simon, features a tower rising four and a half stories above street level. (Longshaw Card.)

SCENES FROM ENGLISH LANGUAGE CLASSICS: HIAWATHA. Suzanne Miller's nine oil-on-canvas murals illustrate 15 different stories including the biblical Solomon, Longfellow's *Hiawatha* (pictured here), and *The Tempest* by Shakespeare. *Mrs. Wiggs of the Cabbage Patch* shares a panel with *Piers Ploughman*. When the 1937 library was damaged by fire in 1973, the paintings were restored and installed in the new library at 101 Pacific Avenue.

SCENES FROM ENGLISH LANGUAGE CLASSICS: THE FAERIE QUEENE. Miller provided the library with a guide to her subjects that included the quotation that inspired her. This panel depicts *The Faerie Queene* by Edmund Spenser: "Upon a great adventure he was bond, That Greatest Gloriana to him gave, That greatest Glorious Queene of Faerie Land."

SCENES FROM ENGLISH LANGUAGE CLASSICS: PILGRIM'S PROGRESS. A third panel is taken from John Bunyan's *Pilgrim's Progress*. It shows the Doubting Castle: "The owner whereof was Giant Despair, and it was in his grounds they now were sleeping." Artists involved with federal projects were expected to consider the setting when choosing subjects for their murals. Quotations from books were an obvious choice for libraries.

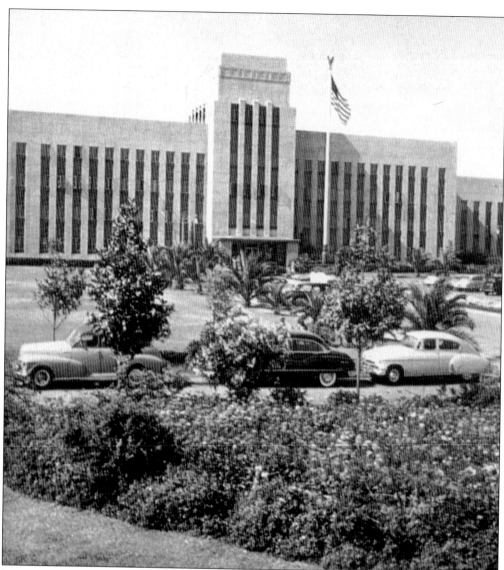

NAVAL HOSPITAL. Chief nurse Ada Allen inspected a perfect line of dedicated naval nurses at the commissioning of the Long Beach Naval Hospital on December 15, 1942. The hospital was designed as "a haven of solace, refuge, and recovery for those who have borne the brunt of battle," said Captain Helm in his speech. Not all their patients arrived due to military injuries, however. In 1943, the first husband of Wallis Simpson, the Duchess of Windsor, was taken there with a knife wound over his heart. Variously ascribed to being stabbed in his bed and "attempting to open a catsup bottle with a butcher knife," the case was closed for lack of evidence. The hospital, constructed by R. E. Campbell's company, closed in the 1990s when the navy left town. (Colourpicture Publication Company.)

ST. MARY'S HOSPITAL
LONG BEACH, CALIFORNIA

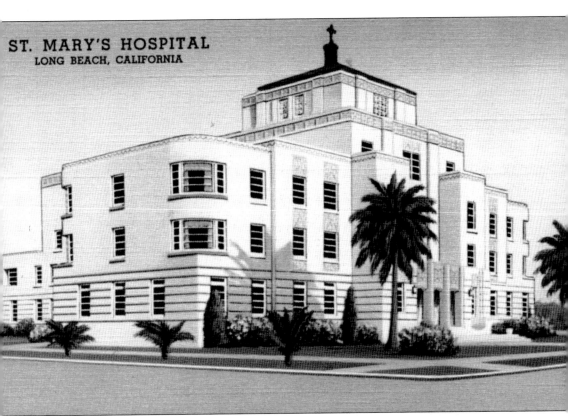

St. Mary's Hospital. In 1929, the Depression derailed a plan by the Sisters of the Incarnate Word to expand their small clinic at Tenth Street and Linden Avenue. The money just was not available for the improvements they hoped to make. Four years later, the building fell victim to the quake. An entire wall collapsed, exposing the room where surgeons continued to operate, but all patients were moved to safety. The building had to be totally demolished. A new 100-bed hospital, with Deco-meets-Celtic crosses over the entrance, opened in 1937, financed by a PWA loan. Architect I. E. Loveless obviously understood the needs of hospitals as he also provided plans for San Bernardino Hospital and St. John's Hospital in Santa Monica. He created a structure that was earthquake resistant, fireproof, and designed for safety—all without sacrificing aesthetics. The hospital has been enlarged over the years, but the post-quake building is still in use. (Genuine Curteich, Chicago.)

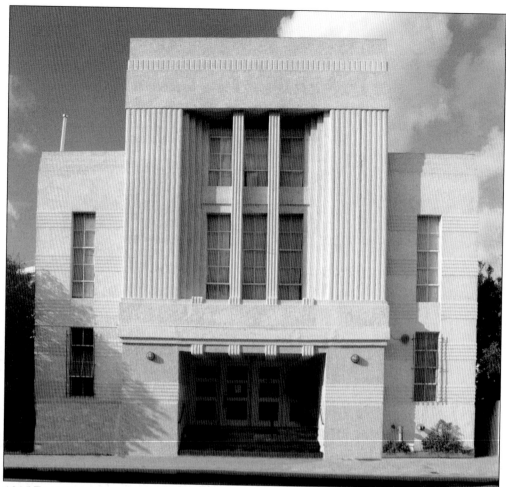

1005 East Sixth Street. Built in 1932 for the Arthur L. Peterson Post of the American Legion, the lodge also housed Pyramid No. 43 of the Ancient Egyptian Order of Sciots of Long Beach. In November 1932, they hosted a convention that included a parade with illuminated floats and 200 costumed beauties. The plan was to wend their way twice around the Rainbow Pier while battleships in the background cast searchlight beams skyward in a spectacular display. A play staged in Sciots Hall in 1954 featured Willie, a stagestruck goat rescued from the animal shelter. It was uncertain what his fate was after the show closed, but every time he was untied backstage he tried to make another entrance—quite a ham of a goat. The building has since been adapted for residential use.

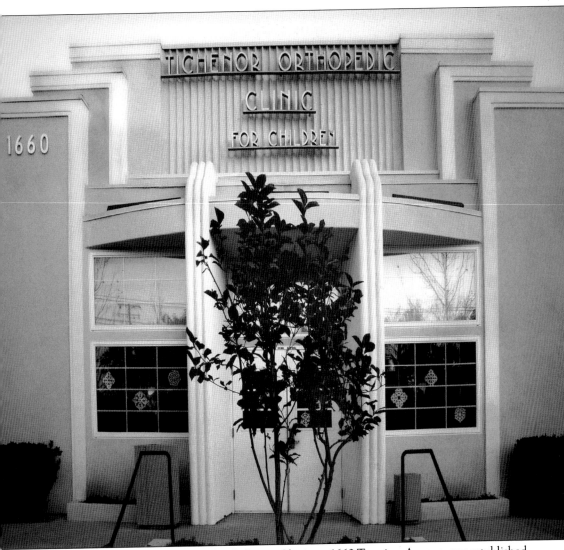

TICHENOR ORTHOPEDIC CLINIC. The Tichenor Clinic, at 1660 Termino Avenue, was established in 1926. It was a legacy from Adelaide Tichenor, a wealthy society woman whose obituary called her the "mother of Long Beach clubs." She was one of the founders of the Long Beach Ebell Club and the City Club and was active in other civic organizations. Among her accomplishments was founding the first public library in Long Beach. When she turned it over to the city, she prevailed upon Andrew Carnegie to donate $30,000 to house the books. One of her lifelong dreams was to establish an orthopedic hospital for children, and her will provided the funds. The formal opening of the clinic was for handicapped children only, as the public was not invited. The clinic moved to its current quarters, tastefully designed by W. Horace Austin, in 1938. His plans included treatment rooms, a gymnasium, two swimming pools, recreation rooms, dressing rooms, and offices.

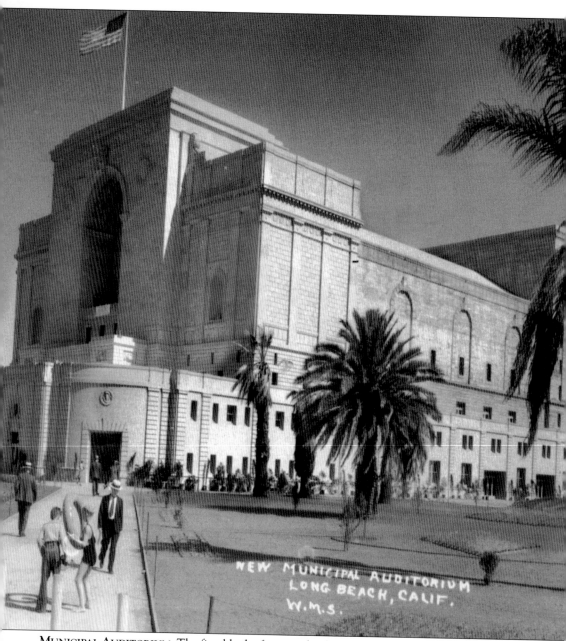

NEW MUNICIPAL AUDITORIUM
LONG BEACH, CALIF.
W.M.S.

MUNICIPAL AUDITORIUM. The first block of granite for the horseshoe breakwater surrounding the municipal auditorium was presented to the city, per a *Los Angeles Times* writer, in "an especially constructed chest bearing the cards of practically all the civic organizations of the community" during the Pacific Southwest Exposition of 1928. The chest was to be placed in the cornerstone of the new building designed by J. Harold McDowell. No mention of the box was made when the auditorium, in its unique and dramatic setting, was torn down in the name of civic progress. The architect's description of the newly opened auditorium was, "The building as it now stands completed at the extreme end of American Avenue, silhouetted against the waters of the Pacific Ocean, offers the most unique setting of any public building in America. . . . It is expected to serve as the seat for many a national assembly in future years." (Postcard uncredited.)

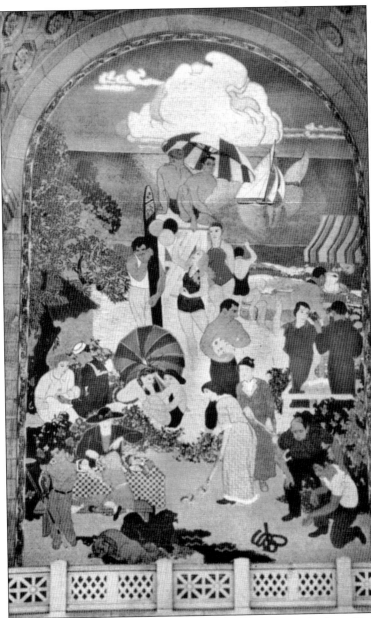

MUNICIPAL AUDITORIUM MURAL. A total of 466,000 bits of clay, with about 90 percent of the tiles made by Gladding-McBean, went into a mosaic depicting life in Long Beach. Art critic Arthur Millier wrote that the huge mural, begun by Henry Allen Nord and carried on by Stanton MacDonald Wright and Albert Henry King, depicts "typical Long Beach pursuits . . . sailing, picnicking, pitching horseshoes." A sailor with his wife and baby represent the navy. The people depicted wear the clothes and strike the attitudes of their time. It was believed that mosaic, an ancient technique, would be particularly suitable for the bright sunlight of Southern California. Changing the shape of each tile for each pattern was Stanton MacDonald Wright's innovation. Once visible for at least a mile over the entrance of the Municipal Auditorium, a community effort rescued the mural when the building was torn down. The mosaic now resides at Third Street and Promenade. (Drown News Agency, E. C. Kropp Company.)

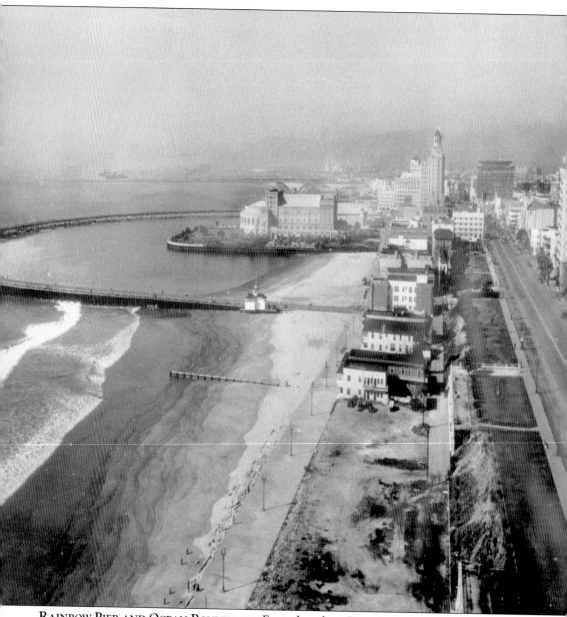

RAINBOW PIER AND OCEAN BOULEVARD. Extending from Pine Avenue to Linden Avenue, the Rainbow Pier enclosed 40 acres of water, affording still-water bathing, boating, sports, a water carnival area . . . and occasionally skinny-dipping, as a 1947 headline, "Bathers Clad Only in Starlight Lose to Police With Flashlight" makes clear. The light poles on the horseshoe pier were painted in a variety of colors, making it a colorful area for strolling, motoring, or celebrating. The pier created a lovely arch, framing the Municipal Auditorium, and was a popular subject for photographers. (Postcard uncredited.)

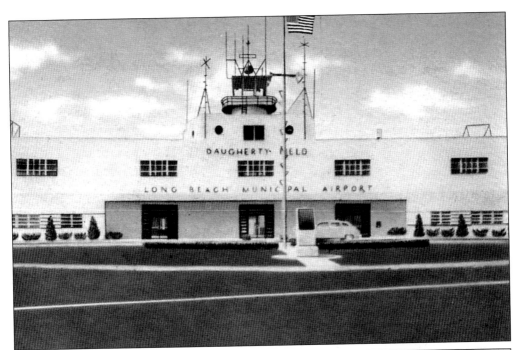

AIRPORT TERMINAL. By late 1941, the year the terminal opened, Marvin Miles pictured Long Beach Municipal Airport as a "gray-green forest of fighting planes" appearing and vanishing "on the long hop toward Allied training fields or European battle skies." The terminal, designed by W. Horace Austin and Kenneth Wing in a style that bridges Streamline Moderne and International style, resembles another form of transportation—the ship. (Advertising Pencil Company.)

AIRPORT STAIRWAY. The interior art was created by 28-year-old Grace Clements for the WPA. The *Los Angeles Times* stated, "Her designs complement the geometrical simplicities of the building and refer intelligently to matters akin to aerial communication." A later article described school children learning about airplane flight plans from "a most unusual 'blackboard'—an air map of the world laid out on the floor in ceramic tile."

ZODIAC MURAL. Clements's tile work once covered the 4,300-foot concourse on the first floor, stair landings, second-floor corridor, and restaurant entry, but most have been destroyed or buried under carpet. Her murals, including a continuous one over three walls of the restaurant of constellations and the mythological figures for which they were named, have been removed or painted over. Grace Clements studied art in New York with Kenneth Hays Miller and Boardman Robinson. After moving to Los Angeles in 1930, she aligned herself with the small Post-Surrealist movement founded by Lorser Feitelson and Helen Lundeberg. Merle Armitrage was highly complimentary of her solo exhibition at the Los Angeles County Museum of Art in 1931, saying, "It will be interesting to watch the progress of this young woman who has already gone so far, who has such a definite and courageous idea of where she wants to go." After her marriage in 1938, it appears she abandoned painting.

Six

SCHOOLS
LEGISLATIVE STATUTES REQUIRE CHILDREN TO ATTEND SCHOOL

Ironically, razing and rebuilding schools and other structures provided much-needed work for men and women who were as devastated by the Depression as the city was by the earthquake. All over the country, schools and public buildings were erected using federally financed workers and funds. WPA Moderne style became so ubiquitous for schools that even Bart and Lisa from the cartoon *The Simpsons* go to school in an Art Deco building. Schools, which are dependant on voter-approved bonds and public funds, are rarely, if ever, torn down or remodeled just for reasons of fashion, although issues of size and safety may precipitate changes. Because Long Beach lost so many educational buildings in the quake, the city has a superb collection of schools representing all facets of Art Deco. Many are in the style most often identified with the WPA, while others are Streamline Moderne or various Revival styles. The government also employed artists to do what they did best, be it painting or sculpture. Schools are repositories of some of the finest public art, particularly murals. Sculpture is also represented, most often by bas-reliefs that surround doors or surmount windows. Sometimes even the most meticulously Revival-style buildings contain artwork that is emblematic of the time.

A VISIT TO THE JUNGLE. After months of experimentation, 1938 ushered in a process for applying paint to plaster without destroying acoustic properties. This had been a problem for artists painting murals in public places, as aesthetics had to be compatible with function and paint filled the small holes that gave the plaster its acoustic properties. WPA artist Suzanne Miller was the first to use the new technique in a mural entitled *A Visit to the Jungle*, which illustrates a story Miller had written in which three children encounter a variety of wise and friendly animals. Architect E. J. Baume added 12 classrooms to Jane Addams Elementary School, located at 5320 Pine Avenue, in 1936.

LOWELL ELEMENTARY SCHOOL. "Buildings cannot be made earthquake proof but they can be made of such resilient qualities that a shock . . . will neither endanger life nor the structural stability of the building," said Edward L. Mayberry in 1927. As one of the technical experts who investigated the catastrophic collapse of the St. Francis dam in 1928, he was very aware of the dangers posed by earth movement. Mayberry put his discoveries to good use in many structures, including a 1935 gymnasium, which was part of the school at 5201 East Broadway. Other buildings at the site were by Wright and Gentry in 1929.

ROOSEVELT ELEMENTARY SCHOOL. Theodore Roosevelt stated, "The one thing I want to leave my children is an honorable name." The name over the door at 1574 Linden Avenue is not only honorable, but also stylishly designed by George W. Kahrs in 1934. When Roosevelt was in office, Long Beach teachers had to sign a pledge to "refrain from attending public dances" so as to not to set a bad example for pupils.

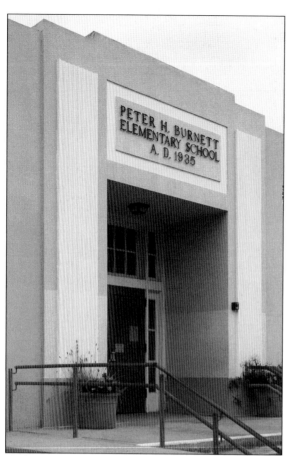

BURNETT ELEMENTARY SCHOOL.
Originally named for Thomas Burr Burnett in an attempt to influence him to build a rail line through Long Beach, the school was renamed to honor Peter H. Burnett, the first governor of California. A contract to construct five classrooms and a kindergarten at 565 East Hill Street was awarded by the board of education to architect D. Easton Herrald and contractor W. J. Esser in 1936.

STARR KING ELEMENTARY SCHOOL.
During the Civil War, it was uncertain whether California would side with the North or South. One man tipped the balance. In 1887, the *Los Angeles Times* wrote, "The cause of the Union needed a great advocate and that advocate was Thomas Starr King." The quake did minimal damage to Piper and Kahrs' 1929 school at 145 East Artesia Boulevard named in his honor.

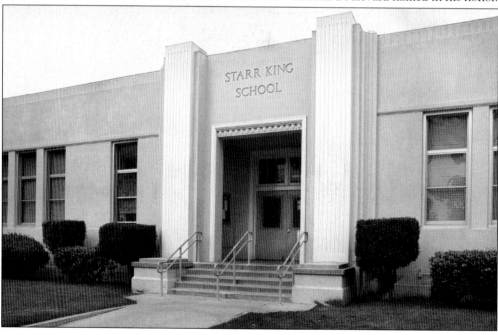

FRANKLIN MIDDLE SCHOOL. The Los Angeles Pressed Brick Company furnished 205,000 tan rug bricks when the Benjamin Franklin School was built in 1925. The instability of the bricks made the W. Horace Austin and John C. Austin–designed structure one of the schools that was completely razed post-quake. George D. Riddle's Regency Deco building at 540 Cerritos Avenue includes several reliefs with flattened figures and a simplified design.

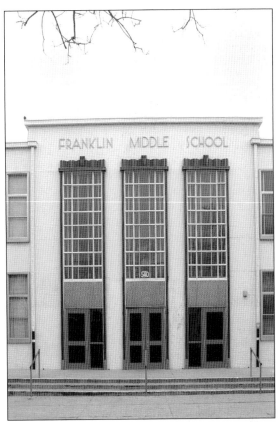

FRANKLIN JUNIOR HIGH GIRLS BASKETBALL TEAM. The girls of Franklin Junior High looked quite fashionable with their bobbed hair when they played basketball in 1927. The 1920s marked the first time when corsets were truly out of fashion and girls were encouraged to participate in active sports. Coco Chanel even made it stylish to have a tan from playing outdoors. The photograph is stamped, "M. J. Ford Photographer, 536 East Fourth."

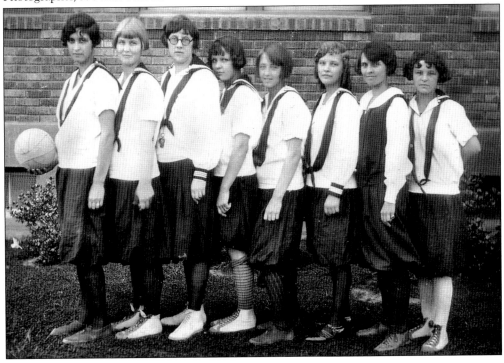

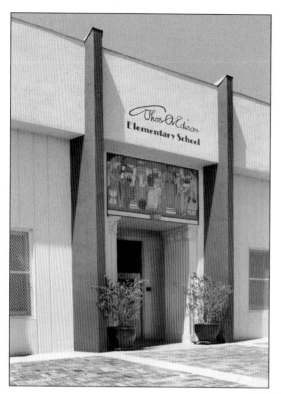

EDISON ELEMENTARY SCHOOL. Located at 625 Maine Avenue, the school with an allegorical cast plaster frieze over the door was designed by Earle R. Bobbe in 1936. The school name above the main entry is an enlarged version of Thomas Edison's signature. A letter to students thanking them for naming a school after him was lost over the years.

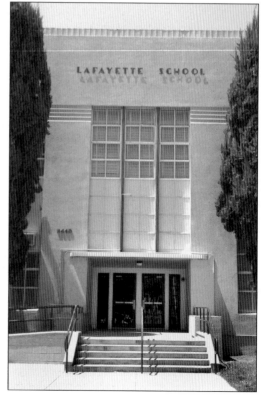

LAFAYETTE ELEMENTARY SCHOOL. In 1933, Cecil Schilling proclaimed, "Vessels move as a unit as they bob up and down and resist strain." He believed that schools, like ships, should be "as strong at one point as another." Plans for a building at 2445 Chestnut Avenue let him test his theory that "seismic disturbance of tremendous intensity might twist and distort them but it would be next to impossible to shake them down."

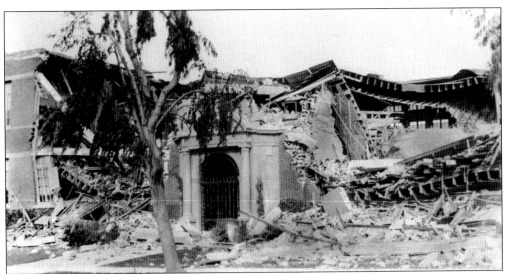

JEFFERSON JUNIOR HIGH SCHOOL. Immortalized on a postcard depicting the destruction wrought by the 1933 quake, the design by eminent Los Angeles architects Allison and Allison with H. Alfred Anderson of Long Beach had been lavishly admired by the *Los Angeles Times* in 1922. Only 11 years old when it fell, the school was constructed of "red, ruffled brick with ornamental cast stone trimmings . . . tile roofs and strictly fireproof halls." (Postcard uncredited.)

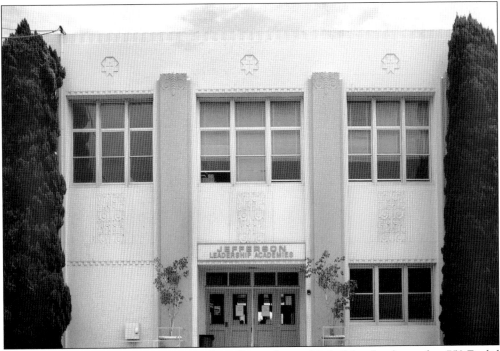

JEFFERSON MIDDLE SCHOOL. By 1936, the Jefferson Junior High School, relocated to 750 Euclid Avenue, rose like a phoenix from the rubble. The Long Beach Board of Education allocated $190,000 for a new and decidedly more earthquake-resistant reinforced concrete school. Warren Dedrick's designs included a shop building, physical education buildings, library, and cafeteria.

LINDBERGH MIDDLE SCHOOL MURALS. In an interview for the Smithsonian, artist Arthur Ames acknowledged that sometimes the place dictates the work and used this mural as an example. He and his wife, Jean Goodwin Ames, designed it under the auspices of the WPA Fine Arts Project. The execution was done by other artists (Serena Swanson, Dorr Bothwell, Elizabeth Mills, and Mary Stanfield) and Goodwin felt that, if anything, they had hewed too closely to the original sketches and that she would have elaborated the details in the process of painting. The 1940 mural, wrapped around the upper wall of the library, shows the history of flight, from the time people gazed with envy at birds to the possibility of space flight.

LINDBERGH MIDDLE SCHOOL. "Lucky Lindy" became a national hero when he became the first man to cross the Atlantic Ocean in his plane, *The Spirit of St. Louis.* On May 31, 1928, he made a surprise visit to Long Beach while making a coast-to-coast survey for a proposed transcontinental plane and train system. He stayed at the Breakers Hotel and toured an aircraft carrier. Lindbergh did not, on that trip at least, visit the school at 1022 East Market Street bearing his name, as it was not open until 1930. At that time, it was the first middle school in Long Beach and was still new when the earthquake leveled it. Its replacement was laid out to resemble an airplane. Above the entry is a bas-relief map showing part of the United States and Europe with Lindy's plane (originally covered with gold leaf lacquer) and May 20, 1927, the date he started his flight.

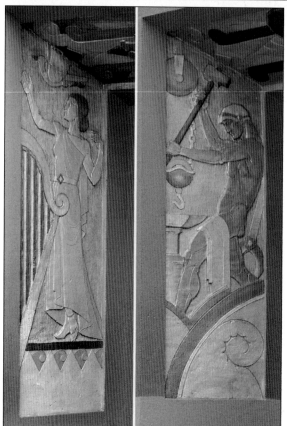

WASHINGTON MIDDLE SCHOOL.
George Washington Junior High, at 1450 Cedar Avenue, did not survive the earthquake, so W. Horace Austin of Long Beach and John C. Austin of Los Angeles drew up plans to replace their previous design. Patriotic eagles flank the steps. The lobby, featuring geometric teal tiles, is finished in Philippine mahogany. Two modernistic chandeliers hang from a ceiling of geometric and floral shapes.

ENTRY BAS-RELIEF PANELS (WASHINGTON MIDDLE SCHOOL).
The areas surrounding the doors at Washington are enhanced by bas-relief sculpture. One door represents music and dance, while the other shows a man at work with a hook and pulley behind him demonstrating engineering technology. Many schools have allegorical figures as decoration, symbolizing the educational values teachers have always wished to impart to their students: wisdom, knowledge, character, and a love of learning.

WOOD SHOP BAS-RELIEF (WASHINGTON MIDDLE SCHOOL). As art critic Arthur Millier pointed out, "Artists say they must eat and insist they paint better than they dig ditches." Hence various New Deal projects put artists to work painting or sculpting. These bas-reliefs are anonymous, but the artist would have been hired under the Public Works of Art Project, the Treasury Department's Relief Art Project, or the Federal Art Project.

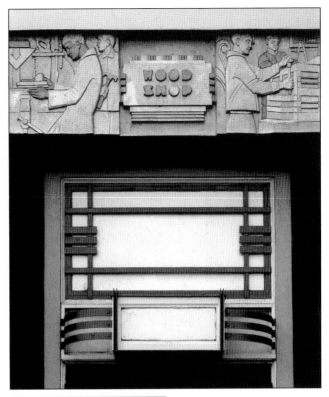

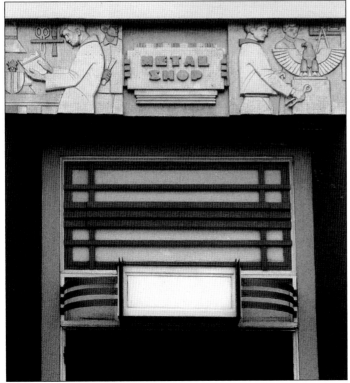

METAL SHOP BAS-RELIEF (WASHINGTON MIDDLE SCHOOL). Millier was part of the committee that directed the projects in Southern California along with other recognizable names, including Cecil B. DeMille, Donald Parkinson, and Merrell Gage. Eleanor Roosevelt was quoted, "I think this plan has tremendous possibilities for awakening the interest of the people as a whole in art. . . . The art of a country is a sign of its virility and strength."

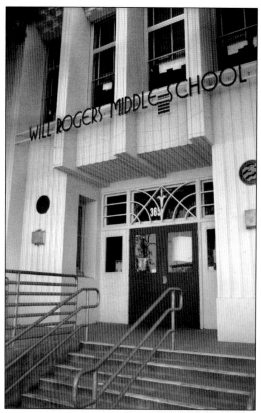

WILL ROGERS MIDDLE SCHOOL. Named for the cowboy humorist who famously said he never met a man he didn't like, other quotes may be more appropriate to a middle school like this at 356 Monrovia Avenue. Perhaps, "Why don't they pass a constitutional amendment prohibiting anybody from learning anything? If it works as well as prohibition did, in five years Americans would be the smartest race of people on Earth."

WILL ROGERS BENCH. This bench, by an anonymous artist, is made of petrachrome, a technique developed by Stanton MacDonald Wright for federal projects. Interlocking pieces of the composition are cast in colored concrete and then polished when it is complete. Will Rogers, whose portrait appears in the medallion, died in a plane crash in 1935. The school was renamed in his honor in 1940, the first so named in California.

DEEP SEA MAGIC. Will Rogers Middle School is the site of a mural in pastel hues accented with gold and silver leaf. Olinka Hrdy's painting is aptly named. Executed in 1939 in oil on canvas, the squid, sea horses, fish, and seaweed seem to inhabit a magical realm. Hrdy was born in Prague, Oklahoma, in 1902 and studied at the University of Oklahoma. Following graduation, she worked as a muralist in Tulsa, Oklahoma, for architect Bruce Goff. In the early 1930s, she managed Frank Lloyd Wright's studio and estate, Taliesin East, in Wisconsin. She moved to Los Angeles in 1933 and worked as an artist for the Federal Art Project, which included this mural. She was also a gardener, and in 1966, she had a different kind of magic when her garden of nearly 100 night-blooming cereus spread their flowers in a single night. In the 1960s, she was the chief designer for the State of California. She returned to her native Oklahoma in 1980 and passed away in 1987.

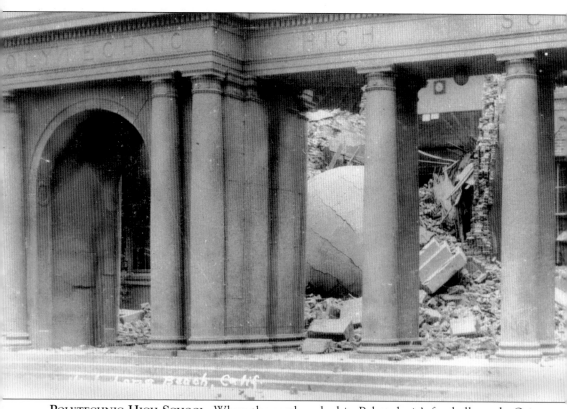

POLYTECHNIC HIGH SCHOOL. When the earthquake hit, Polytechnic's football coach, Orian Landreth, had just left his house to referee a basketball game. He rushed home in time to save his infant daughter. The water polo teams of Poly and Fullerton left the pool minutes before the roof collapsed. One of the school's former star-tackles always boasted that he was "the greatest waterboy in Poly football history." He proved it by carrying "pure water in pails to both hospitals for forty-eight consecutive hours without spilling a drop." Three weeks after the quake, beach umbrellas sprouted on the athletic fields as tents became temporary classrooms. (Postcard uncredited.)

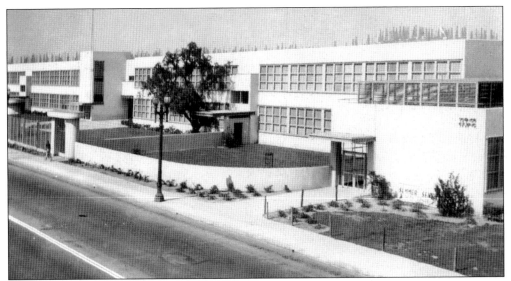

POLYTECHNIC HIGH SCHOOL. Although the earthquake left the auditorium at 1600 Atlantic Avenue standing, architect Hugh R. Davies chose to remodel it in October 1933 to bring it into harmony with the "strength and simplicity" of his million-dollar design for the new high school. His design for the school has much in common with the Modernist style, but the maritime details reveal the 1930s preoccupation with speed. (Postcard uncredited.)

POLYTECHNIC HIGH SCHOOL DOORS. The entry to one of the classroom buildings features simplified portraits of figures from history. Abraham Lincoln, for example, is second from the top at left. The sculptor is unknown.

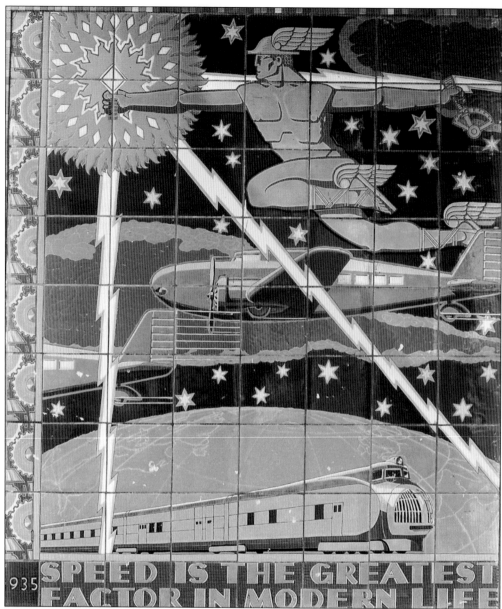

SPEED IS THE GREATEST FACTOR IN MODERN LIFE. This 1935 ceramic-tile mural at Polytechnic is, unfortunately, anonymous. Its theme and design are so perfectly emblematic of the Machine Age as Mercury speeds through the sky, racing both a Douglas DC-1, which was the first commercial-passenger airliner, and a Union Pacific train with aerodynamic lines that captured the imagination of the crowds at the 1933 Chicago World's Fair. Lightning bolts add to the excitement of speed. Polytechnic High also boasts a mural painted under the auspices of the WPA Federal Art Project. Jean Swiggett and Ivan Bartlett, both alumni of Poly, painted the egg tempera on plaster mural in 1938, entitled *Industrial Activities*. Long Beach was hurt less by the Depression than many cities and the painting depicts several of the city's industries: shipping, fishing, oil, and the U.S. Navy's Pacific Fleet.

PRESERVATION IN LONG BEACH

Every day history slips away. When a building is demolished it's gone forever, along with any clues to the past that it contains. One person can make a difference. The best way to help is to join and volunteer for one of the local organizations listed here. While the focus of some of these groups may be different, their larger goal is the same—preserving the historic architectural structures of Long Beach.

Art Deco Society of Los Angeles
P.O. Box 972
Hollywood, California 90078
310-659-3326
http://www.adsla.org

Historical Society of Long Beach
110 Pine Avenue, #1200
Long Beach, CA 90802
562-495-1210
http://www.historicalsocietylb.org

Long Beach Heritage
P.O. Box 92521
Long Beach, CA 90809
562-493-7019
http://www.lbheritage.org

Long Beach Heritage Museum
P.O. Box 14641
Long Beach, CA 90803
http://longbeachheritagemuseum.com

Los Angeles Conservancy
523 West Sixth Street
Suite 826
Los Angeles, CA 90014
213-623-2489
http://www.laconservancy.org

Queen Mary RMS Foundation
1126 Queens Highway
Long Beach, CA 90802
562-435-3511
http://www.queenmary.com

ACROSS AMERICA, PEOPLE ARE DISCOVERING SOMETHING WONDERFUL. *THEIR HERITAGE.*

Arcadia Publishing is the leading local history publisher in the United States. With more than 3,000 titles in print and hundreds of new titles released every year, Arcadia has extensive specialized experience chronicling the history of communities and celebrating America's hidden stories, bringing to life the people, places, and events from the past. To discover the history of other communities across the nation, please visit:

www.arcadiapublishing.com

Customized search tools allow you to find regional history books about the town where you grew up, the cities where your friends and family live, the town where your parents met, or even that retirement spot you've been dreaming about.